VOICES *of* SUDAN

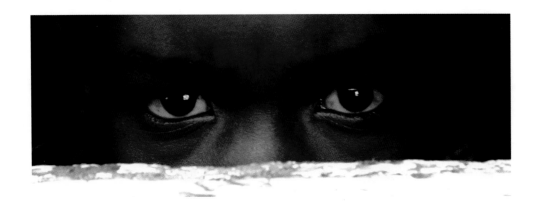

WRITING & PHOTOGRAPHY BY DAVID JOHNSON

Published by Elevate, Charleston, South Carolina.
Member of Advantage Media Group.

ELEVATE is a registered trademark and the
Elevate colophon is a trademark of Advantage Media Group, Inc.

Printed in Seoul, South Korea

ISBN: 978-1-60194-010-0

Most Advantage Media Group titles are available at special quantity discounts for bulk purchases for sales promotions, premiums, fundraising, and educational use. Special versions or book excerpts can also be created to fit specific needs.

For more information, please write: Special Markets, Advantage Media Group, P.O. Box 272, Charleston, SC 29402 or call 1.866.775.1696 or visit www.silentimages.org.

Library of Congress Cataloging-in-Publication Data

Johnson, David, 1975-
 Voices of Sudan / by David Johnson.
 p. cm.
 Includes bibliographical references and index.
 ISBN 978-1-60194-010-0 (alk. paper)
 1. Sudan–Pictorial works. I. Title.
 DT154.67.J64 2007
 962.404'3–dc22

 2007018205

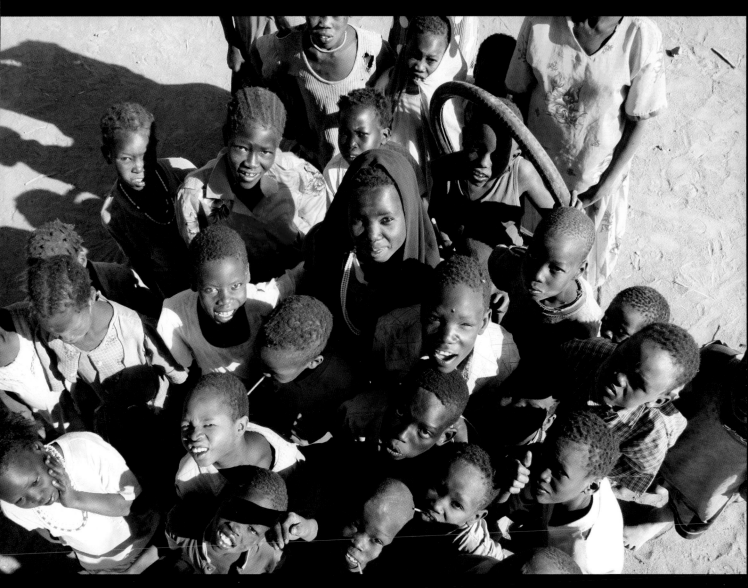

By purchasing this book, you have helped pay for food, water, and medicine for the people of Sudan. For the Sudanese, who have no voice, I say, "Thank you."

David Johnson

WWW.SILENTIMAGES.ORG

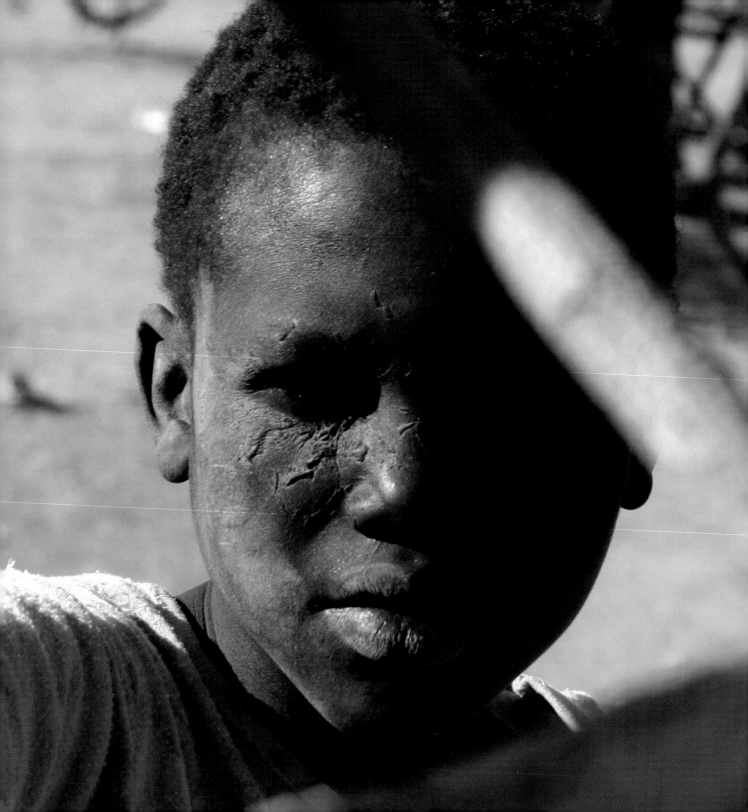

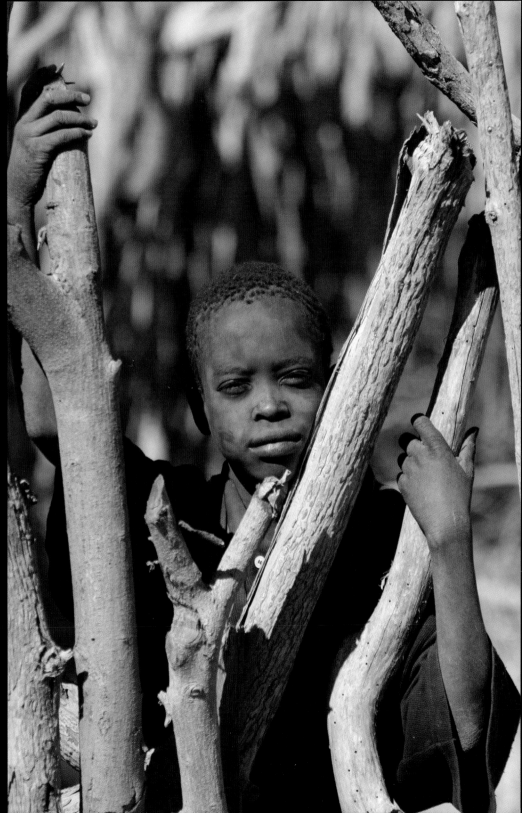

"More people have
been killed by the jihad
in Sudan than all of
the victims of Bosnia,
Kosovo, Rwanda, and
Somalia combined, yet
the media has not told us
the story of Sudan."
(PPF Video)

BRAD PHILIPS
Director of Persecution Project

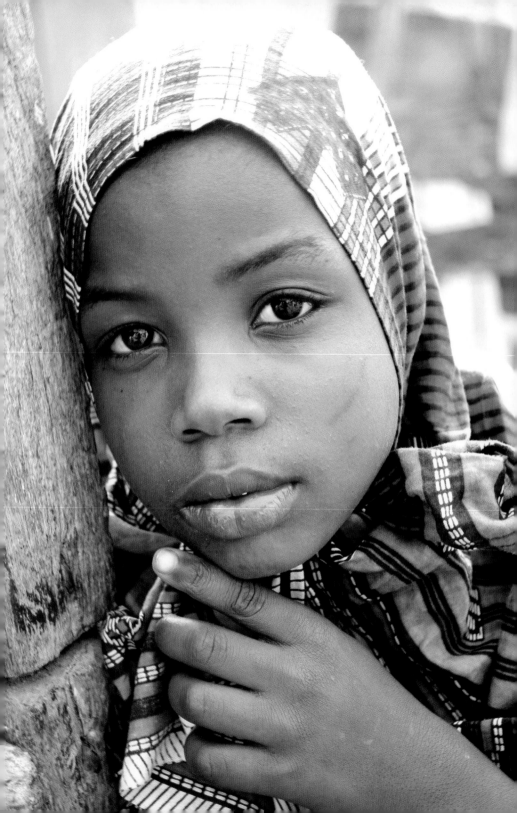

CONTENTS

PHOTOGRAPHY

I HAVE PHOTOGRAPHED SOME OF THE MOST TRAGIC PLACES in our world. I served in the worst slum areas of Brazil and Kenya, roamed the killing fields of Cambodia, crept through the jungles of Vietnam, participated in tsunami relief in Thailand, and walked the hallowed beaches of Normandy. Each of these places carries a reminder of an event that speaks of a tragic human condition. The Sudanese, whose story is on these pages and in these photographs, live in the worst human condition I have ever photographed.

The camera's uncensored lens speaks out for those who can no longer speak for themselves. Images force us to confront the reality of a moment in time. We cannot ignore the human beings who stare at us from these pictures and then dismiss the images as a ploy to push a political agenda. Images do not distract with abstract numbers; instead they force us to wrestle with the human condition captured here. Sometimes images ring with laughter or joy, sometimes they yell out with courage and strength, and at other times they cry out for help. When we interact with these images, we have two choices: ignore the voices and return them to their current condition, or we help restore the power of their voices by choosing to do something.

BACKGROUND

IN 2007 AND 2008, African Leadership and Persecution Project asked me to accompany them on two trips to Sudan. My assignment was to photograph and document the condition of the Sudanese. Before I took a photograph or asked an individual to share his or her story, I either built a relationship with the person or asked for permission. The photographs and stories are not being documented to rob them of dignity, but to restore power to the voice of the Sudanese.

As our plane barreled down the dirt runway in Darfur, Sudan, I looked out the window at the refugees waving goodbye to us. The roar of the engine and the closed window drowned out the Sudanese voices. I saw their mouths moving and their hands waving, but I could hear nothing. No matter how loudly they screamed, I could not hear their voices. It was at this moment that I decided that something must be done to restore their voices so that they do not remain unheard or ignored.

I sat in the JFK airport when I returned from my six weeks in Africa and watched the news headlines: Anna Nicole Smith's death and Britney Spears' new tattoo. I was furious. Innocent people are starving and being slaughtered, and we muffle their cries for help by focusing on pop culture gossip. Endless political debate and mindless chatter may momentarily distract us, but I am confident that when a person views the images of the Sudanese, they will be moved and offer to help. I missed my connecting flight from New York to Charlotte, so I had an evening in the terminal to brainstorm how I would assist the Sudanese. I told myself, "I must do something with these photographs," and that *something* turned into the book you are holding now.

All I can offer are my photographs. I know that even though these images are unable to physically speak, they tell a story, and they will inspire the viewer to respond. I pray that this work helps to restore a voice to the Sudanese, and the readers of this book will be informed and hearts will be provoked to reach out and help the Sudanese.

SUDAN 1978-2007

1978 Large amounts of oil are found in southern Sudan; this discovery becomes a significant factor in instigating further conflict between the North and the South.

1983 Sudan President, Jaafar Numeiri, introduces Islamic Sharia Law to Sudan, which leads to resistance from the Christian South. Civil war breaks out in the South involving government forces and the Sudan People's Liberation Movement/Army (SPLM/A), led by John Garang.

1985 Numeiri is removed from power in a military coup.

1989 Al-Bashir and his Islamic Front (NIF) takes power in a military coup.

2001 Hunger and famine affect three million people in southern Sudan.

2002 (January) SPLM/A joins forces with a rival militia group, the Sudan People's Army, to pool resources in a campaign against government in Khartoum.

2002 (July 27) President Al-Bashir meets with SPLM/A leader John Garang for the first time to discuss ways of restoring peace to Sudan.

2002 (July 31) Government launches a large-scale attack against the SPLM/A.

2003 (February) The two rebel groups representing the African population in Darfur start a rebellion against the government as a protest for neglect and suppression.

2004 (January) Government army strikes down the uprising in the Darfur region. Hundreds of thousands seek refuge in Chad.

2004 (March) UN official says pro-government Arab "Janjaweed" militias are carrying out systematic killings of African villagers in Darfur. U.S. Secretary of State, Colin Powell, describes Darfur killings as genocide.

2005 Peace treaty signed to end civil war, but the conflict in Darfur continues.

2006 (May) Khartoum government and the main rebel faction in Darfur, the Sudan Liberation Movement, sign a peace accord. Two smaller rebel groups reject the deal. Fighting continues.

2006 (August) Sudan rejects a United Nations resolution calling for a UN peacekeeping force in Darfur, saying it would compromise Sudanese sovereignty.

2007 Over 4 million Sudanese people have been displaced, and more than 2 million have been murdered over a period of two decades. With the combination of genocide and famine, Sudan is now being called the greatest humanitarian crisis on the planet.

FACTS ON SUDAN

SUDAN *is the* LARGEST COUNTRY *in Africa.*

THE DARFUR REGION *is about the size of* TEXAS.

CAPITAL CITY: *Khartoum*

LITERACY: *61%*

ETHNIC GROUPS: *Black 52%*

Arab 39%

Beja 6%

Foreigners 2%

Other 1%

RELIGIONS: *Sunni Muslim 70% (in North)*

Christian 5% (mostly in South and Khartoum)

Indigenous Beliefs 25%

"The international media are rarely afforded opportunities to travel to Darfur owing to stringent travel restrictions imposed by the government. This 'pre-emptive' suppression has meant that many of the atrocities in Darfur have unfolded without being reported in local media."

BEN FRASER
Sudan Journalist

MAP OF SUDAN

"It's simply the case that the Sudanese government needs to recognize that the international community can't stand idly by while people suffer, while we're unable to deliver humanitarian assistance to people and while the violence against innocent civilians continues."

U.S. Secretary of State
CONDOLEEZZA RICE
(March 2007)

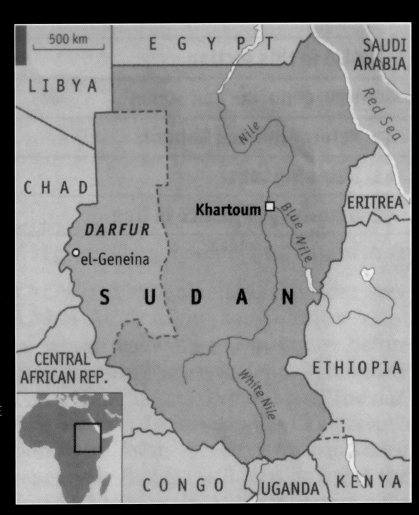

THE WAR

ALTHOUGH THE GOVERNMENT OF SUDAN and the SPLM/A signed a cease-fire in 2005, persecution continues in western and southern Sudan. In Darfur, African tribes rebelled because of neglect and discrimination, and the Arab-dominated government responded and unleashed a militia of Arab nomads. These nomads, called the Janjaweed (which translated means "devils on horseback"), have been slaughtering villages in Darfur since 2003. For three years, the world watched as innocent people were slaughtered in Darfur.

Finally, on July 31 2007 UN Secretary General Ban Ki Moon announced an historic and unprecedented decision to create the UNAMID (UN and African Union Mission in Darfur). This decision by the UN allowed for a hybrid peacekeeping force of 26,000 to restore peace in Darfur. Some critics are less optimistic about Sudan's willingness to cooperate and recognize the limitations of the UNAMID. "Sudan has a long history of obstructing any international presence in Darfur, and U.S. Secretary of State Condoleezza Rice warned that the United States would watch out for any Sudanese backtracking. Western activists warned that Khartoum could eviscerate the new Darfur mission by, for instance, not granting entry visas to blue helmets, holding up key military gear at customs or impeding contractors sent in to build peacekeeping bases" (CNN.com, August 1, 2007).

The fact remains that Sudan, the UN, and non-profit organizations will have years of work ahead of them to restore Sudan to a peaceful state. Until then, Sudanese boys will continue to stare into the barrel of AK 47s. Some of the guns are there to protect them, and some are there to kill them. In either case, they strike fear and remind the boys of the persecution that wages in Sudan.

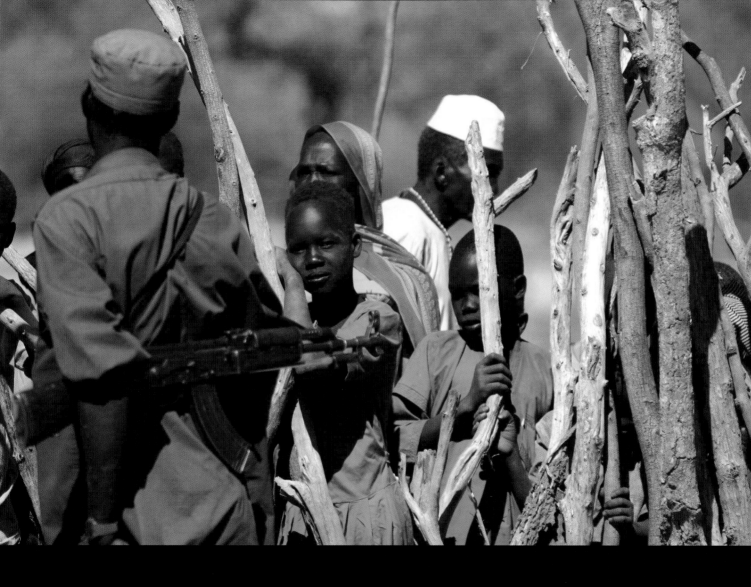

"In the face of constant danger, dwindling resources and only minimal assistance from international aid groups, these die-hard Darfurians are finding ways to cope."
EDMUND SANDERS, *Los Angeles Times* 2007

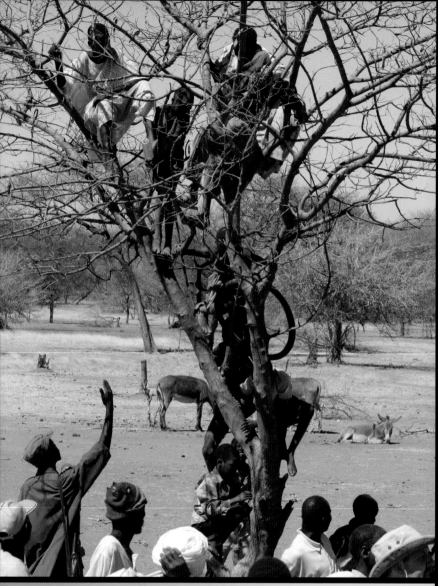

The boys have climbed up a tree to listen to a pastor share a story from the Bible. The SPLA soldier encourages the boys to come down after the message.

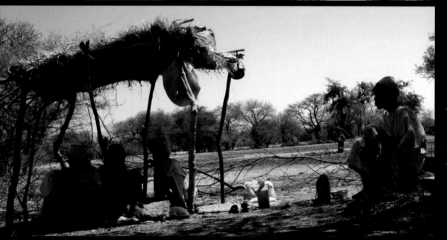

The war has destroyed many of their huts, so thousands of the refugees are now living under trees with minimal shelter.

FRANCIS AYUL and Persecution Project founder, BRAD PHILLIPS, met in 2001 while hiding together from the government troops along the Awilawil River. This was not the first time that Francis was hunted by the government. In 2001 he was shot through his stomach and left for dead in the Sudan desert. He spent three nights alone in the desert, cupping his intestines in his hands and trying to use pressure to slow down the bleeding. He spent the first night throwing stones at the hyenas that were coming to feast on him and nearby corpses, and an evening rainfall brought nourishment and cleansing to his body on the second night. He spent the third evening wrestling whether or not to use one of his twelve remaining bullets to take his own life. He prayed, "God, if you get me out of here alive, I will serve you as long as I live." When the SPLA and villagers came back to collect the dead, they were amazed to find Francis alive. He was evacuated to the Red Cross Hospital in Lokichoggio, Kenya. There he underwent several surgeries to repair his intestines. Today, he is a pastor who continues to make dangerous trips into Sudan to serve the people.

THE PEOPLE

THE REFUGEES CARRY TWO THINGS WITH THEM: faces covered in dirt and eyes filled with pain. Water is precious. It is not wasted on bathing, so they grow accustomed to being dirty and to ignoring the pain. Their tears cleanse their hearts and their faces. The refugee camps are a mix of Dinka Christians, Darfurian Muslims, and Animists. The Radical Islamic terrorists persecute those who are not a pure Arab Muslim, so refugee camps are filled with thousands of people from different backgrounds. The refugees put aside all of their religious and tribal differences and are unified by only one thing… fear.

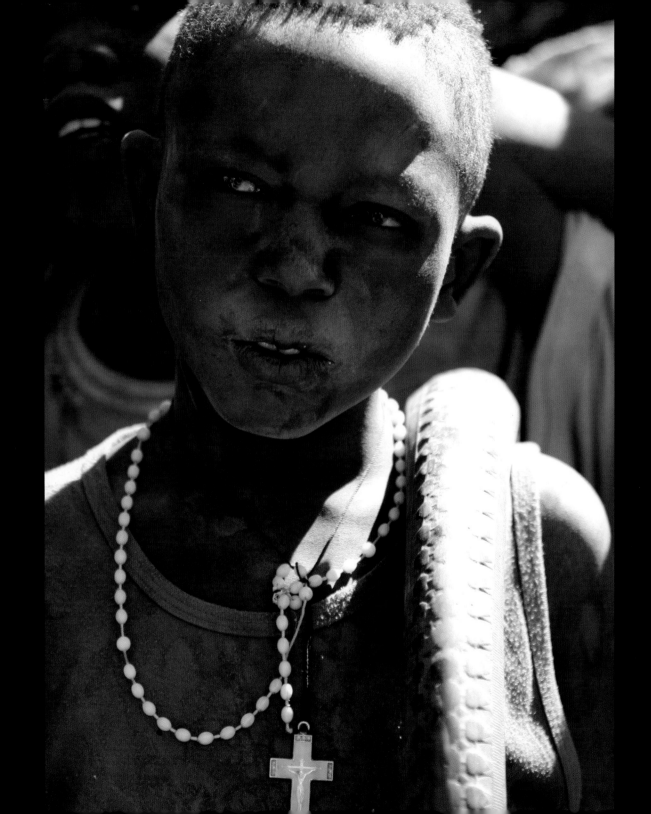

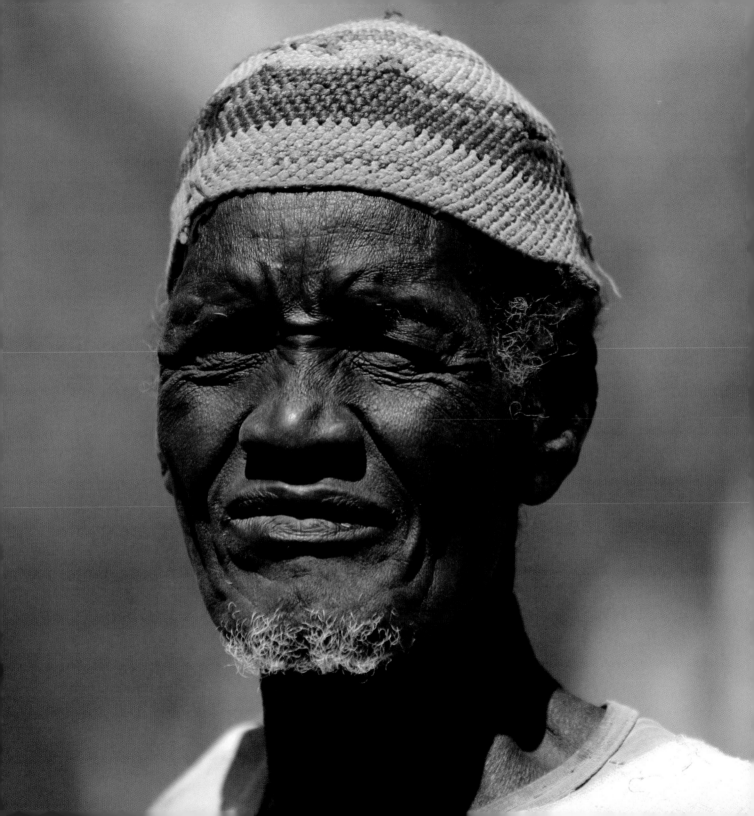

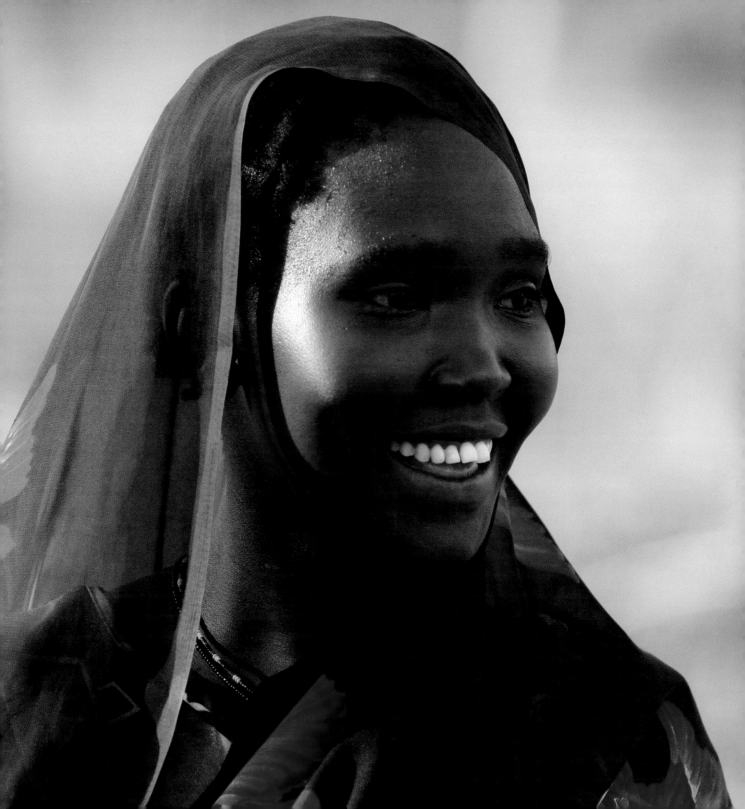

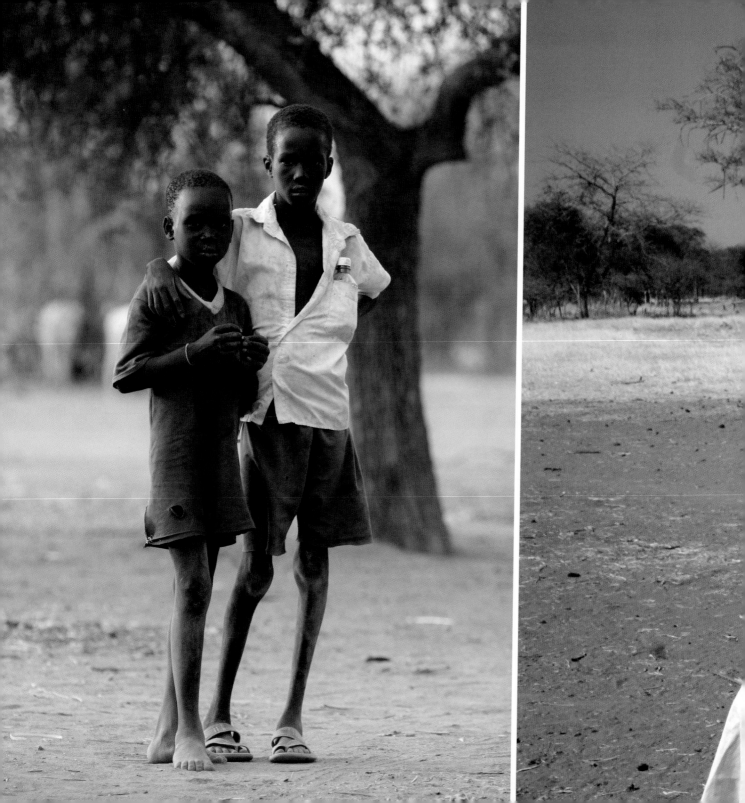

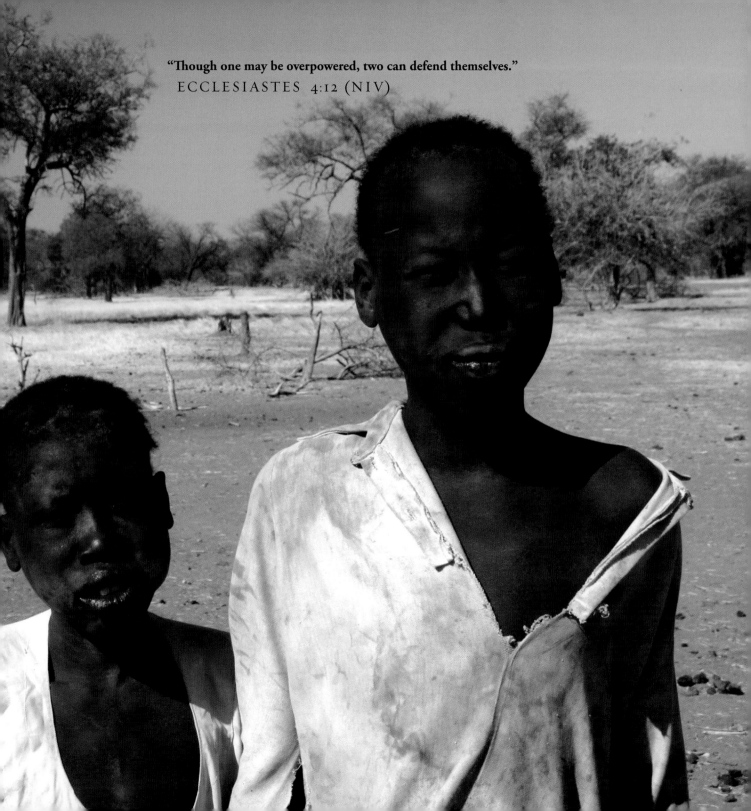

"Though one may be overpowered, two can defend themselves."

ECCLESIASTES 4:12 (NIV)

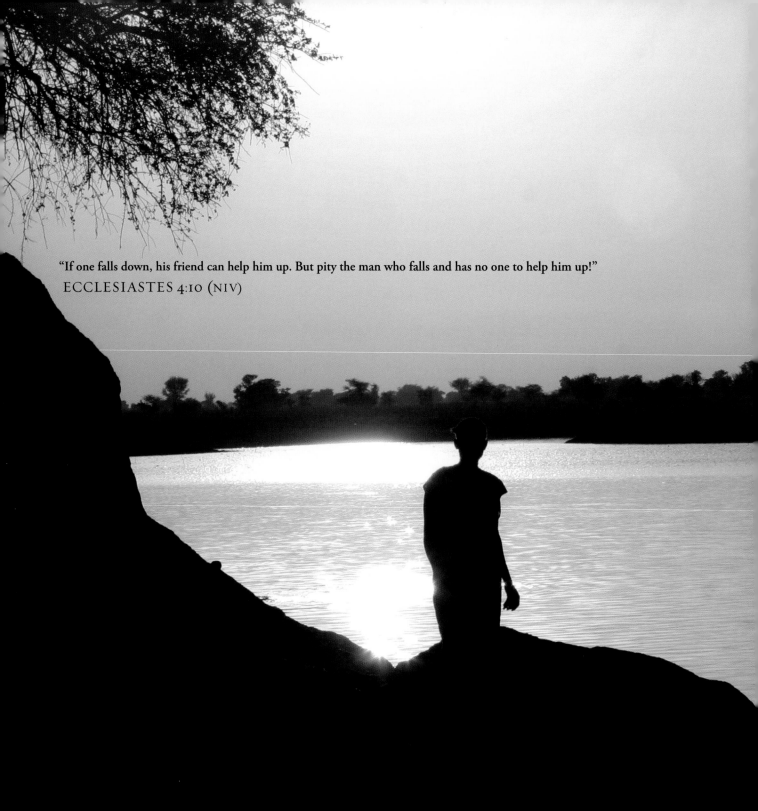

"If one falls down, his friend can help him up. But pity the man who falls and has no one to help him up!"

ECCLESIASTES 4:10 (NIV)

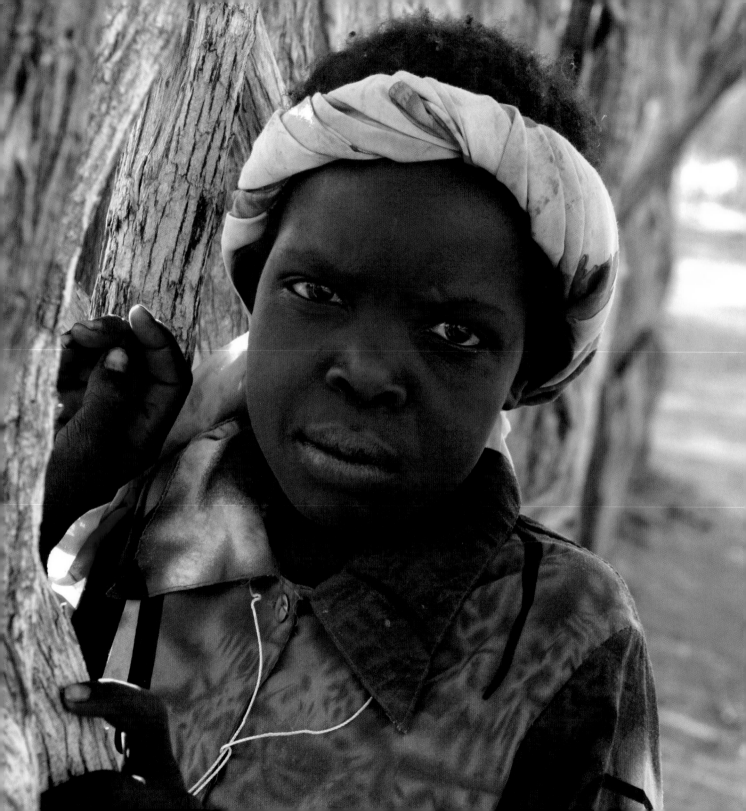

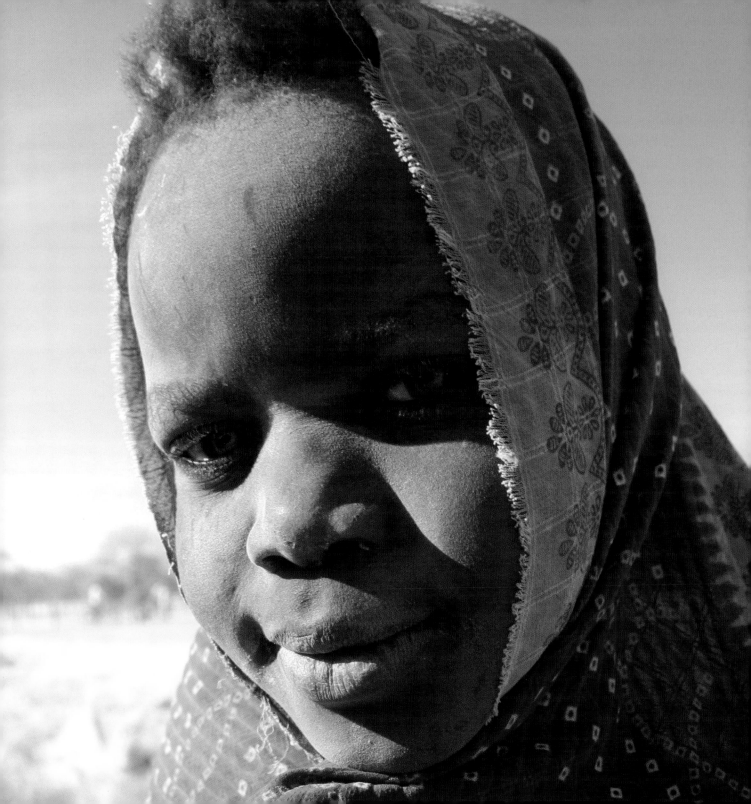

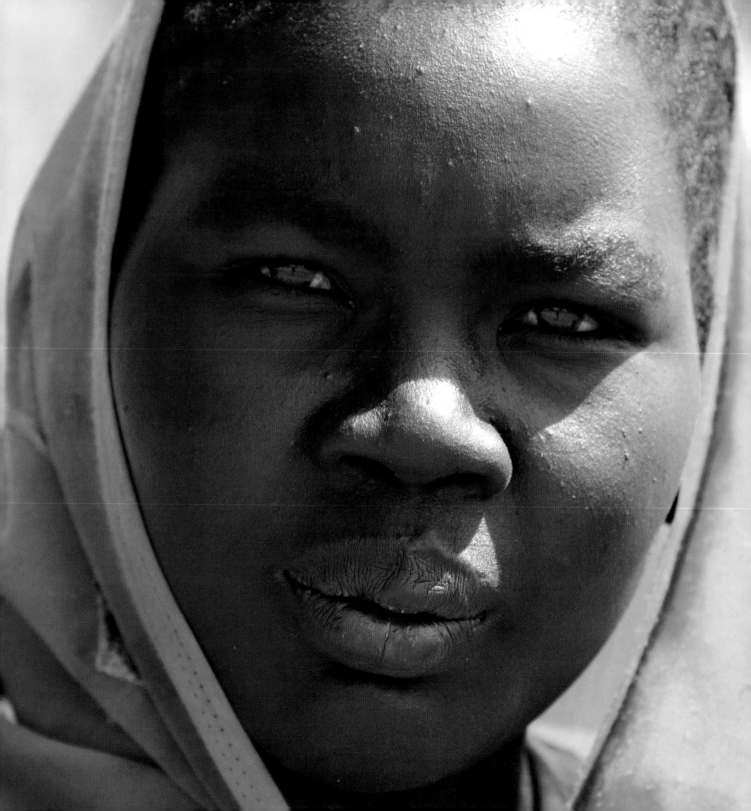

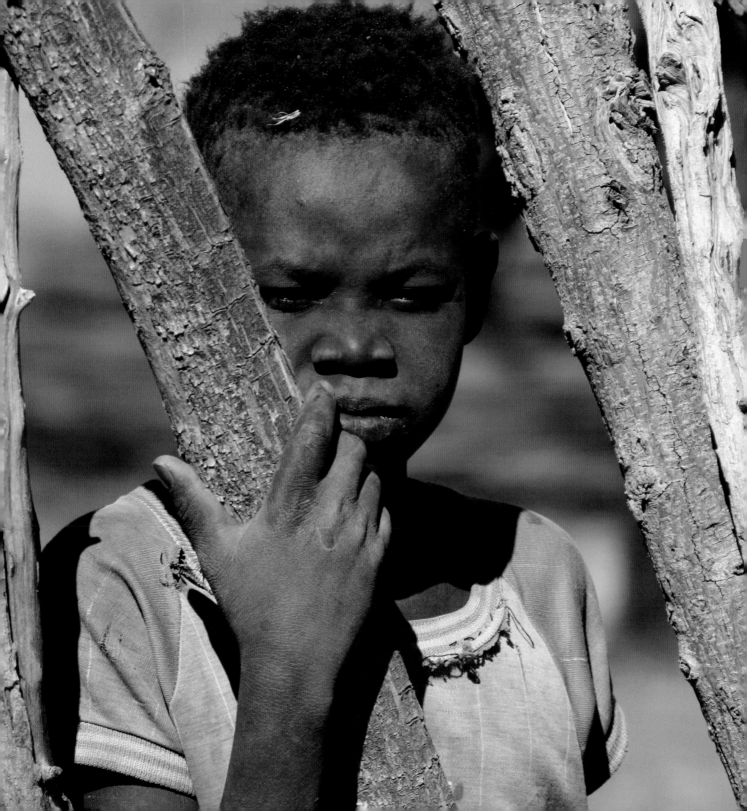

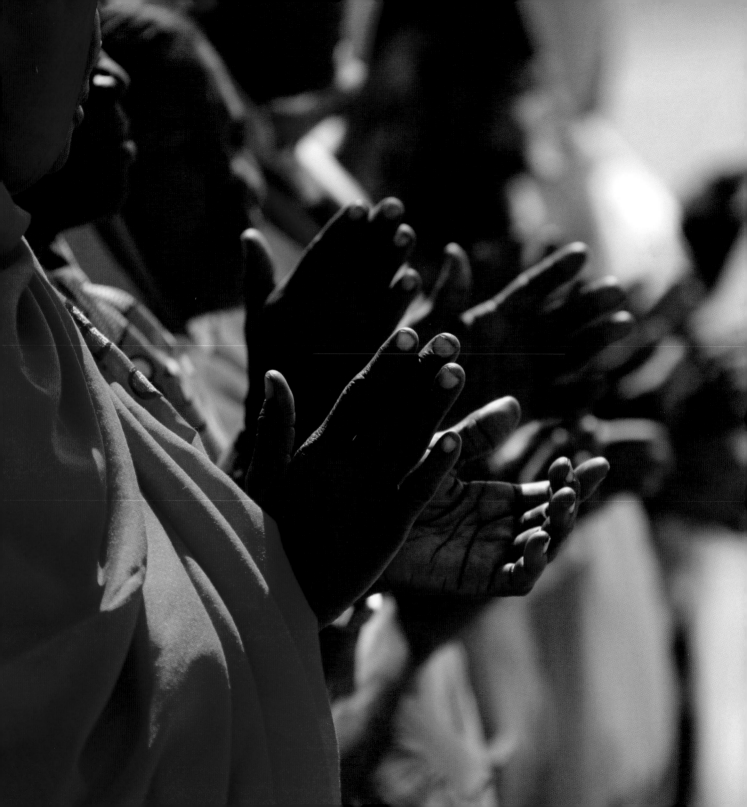

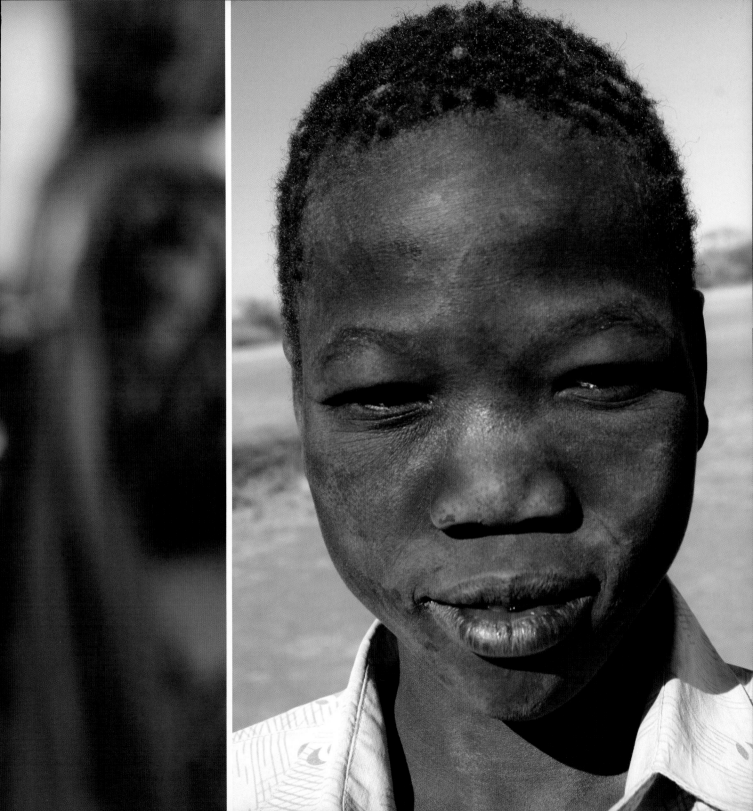

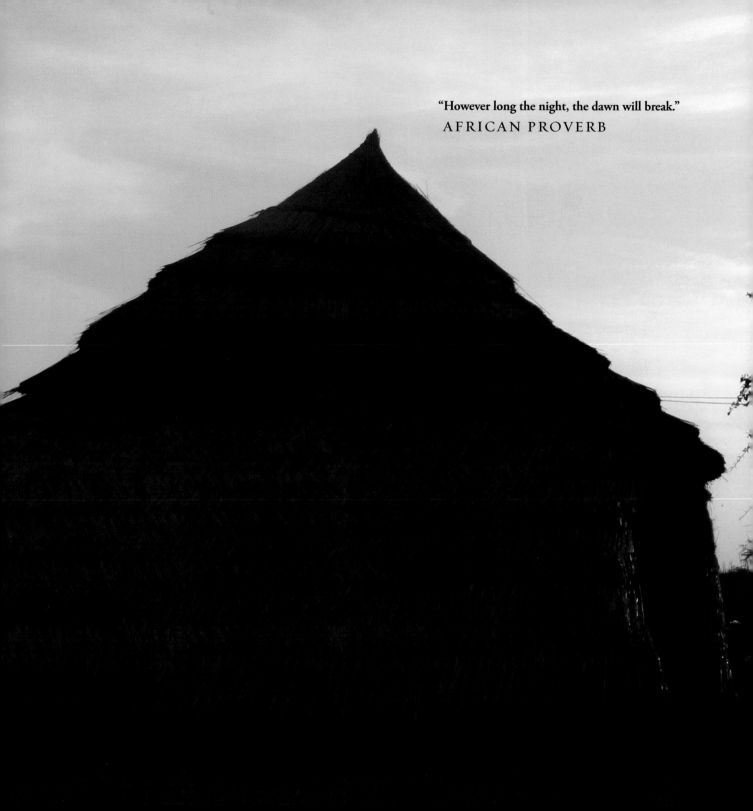

"However long the night, the dawn will break."
AFRICAN PROVERB

WATER

WATER IS SCARCE. The southern Sudanese's greatest resource, the Nile River, is off limits. The NIF (National Islamic Front) does not allow the inhabitants to drink from it; therefore, Sudanese resort to hand digging wells. The woman photographed has climbed into a hole, dug by hand, that provides her family with what we would call mud, which her family drinks. The muddy water she is about to bring to her children is wet enough to sustain life, but it also brings with it dirt and bacteria that kill thousands of Sudanese each year.

If the Sudanese do not hand-dig a well, they must walk to the nearest river to get water, which can be very dangerous. The River Kiir is a two-day walk from this refugee camp. The other alternative is to walk for hours to get to an existing well.

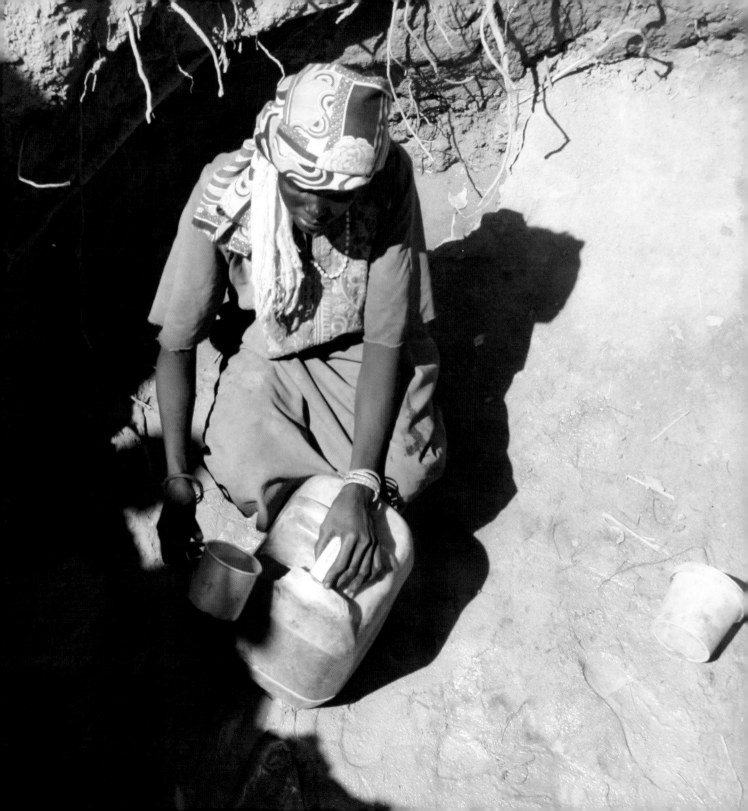

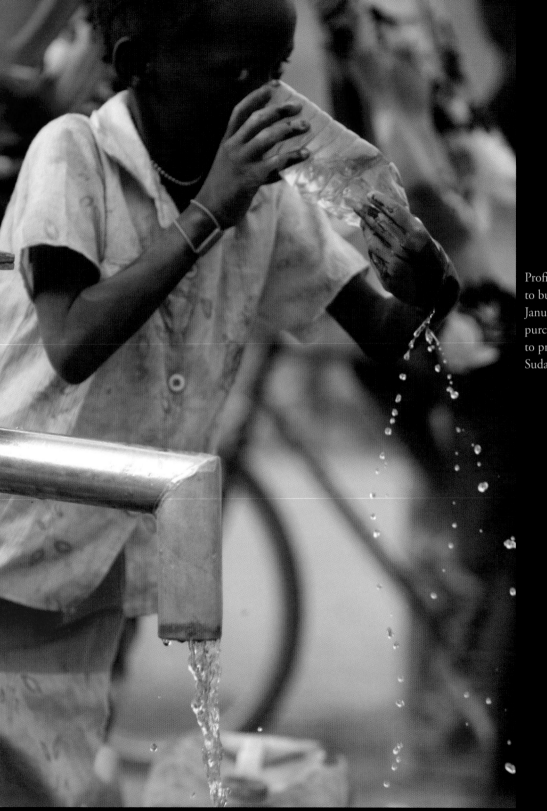

Profit from book sales helped
to build this well in Darfur in
January of 2008. Thank you for
purchasing this book and helping
to provide clean water for the
Sudanese.

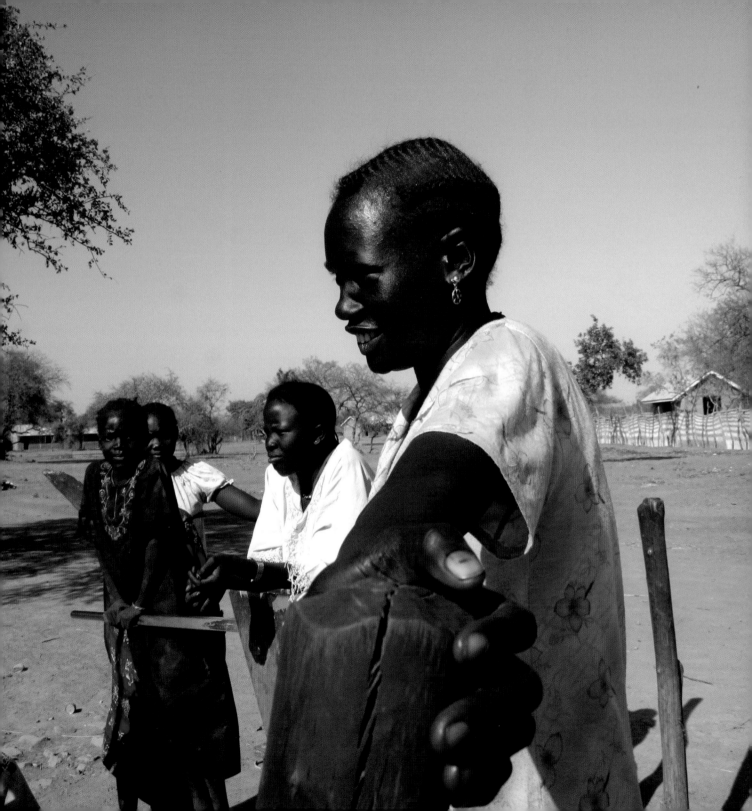

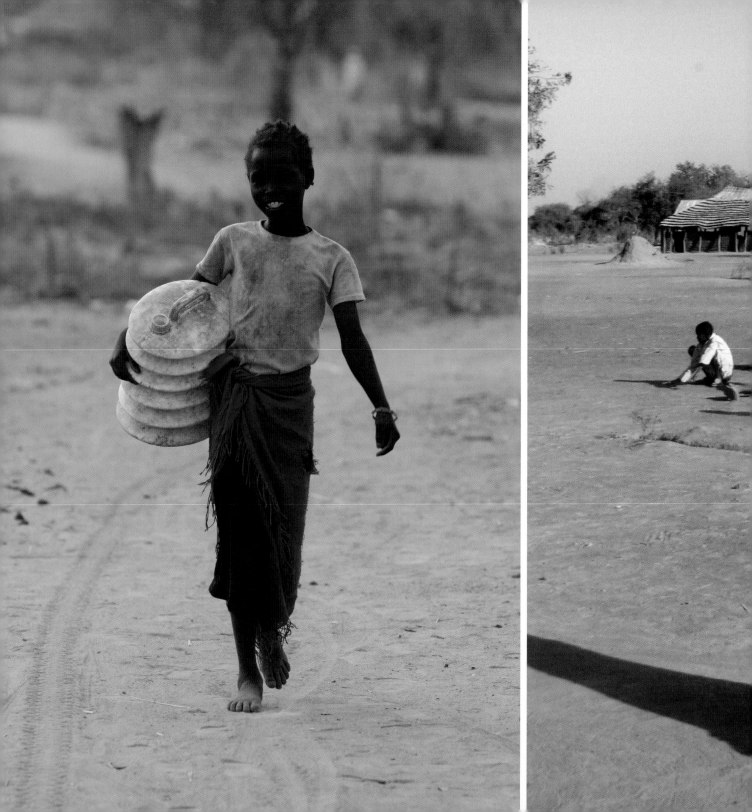

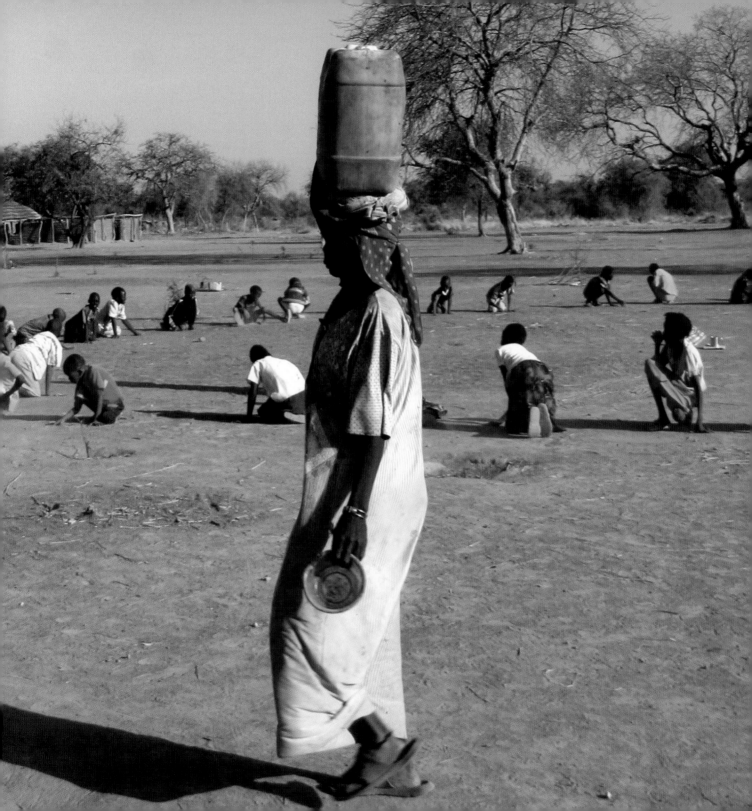

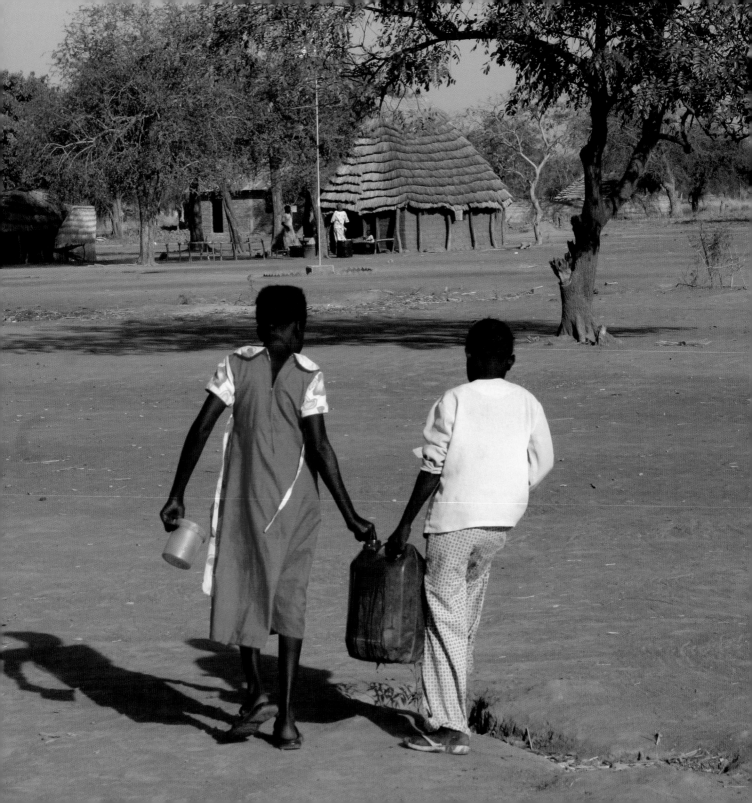

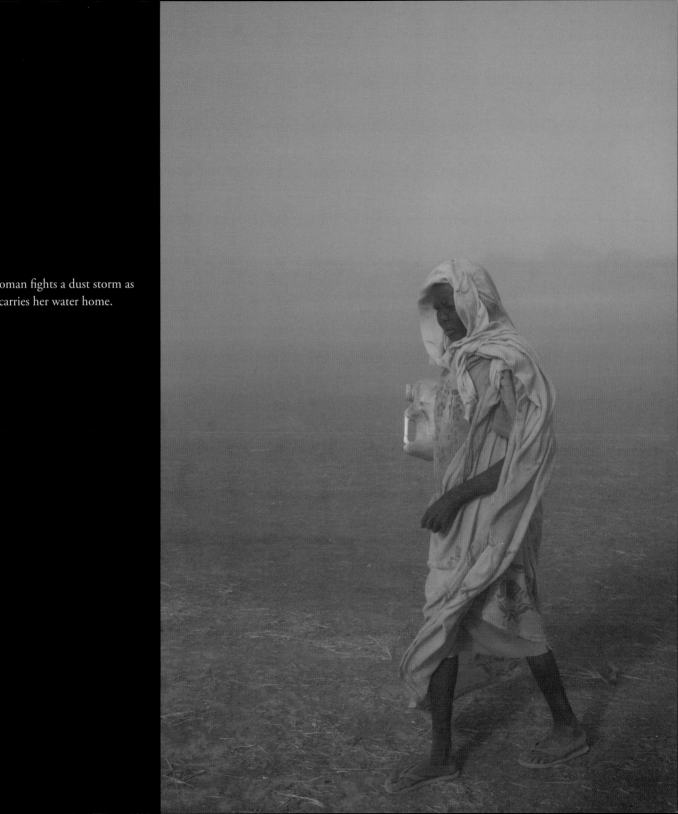

...oman fights a dust storm as ...carries her water home.

SUDANESE WOMEN

WITH SO MANY MEN BEING SLAUGHTERED, Sudanese women are often left behind to protect and provide for the children. Caring for their families keeps women close to their villages, making them easy targets for the Janjaweed. Thousands of women have been raped and sexually abused. Once abducted, the women's legs are broken to keep them from escaping, and their breasts are cut off to keep them from feeding their babies. In refugee camps the women are frequently attacked as they go to the river to collect water or to the bush to collect firewood. The social effects of this abuse cause even more pain. The children and their mothers have to bear the community's sense of shame. Husbands abandon their wives after they have been raped, and women are branded as "unworthy of marriage."

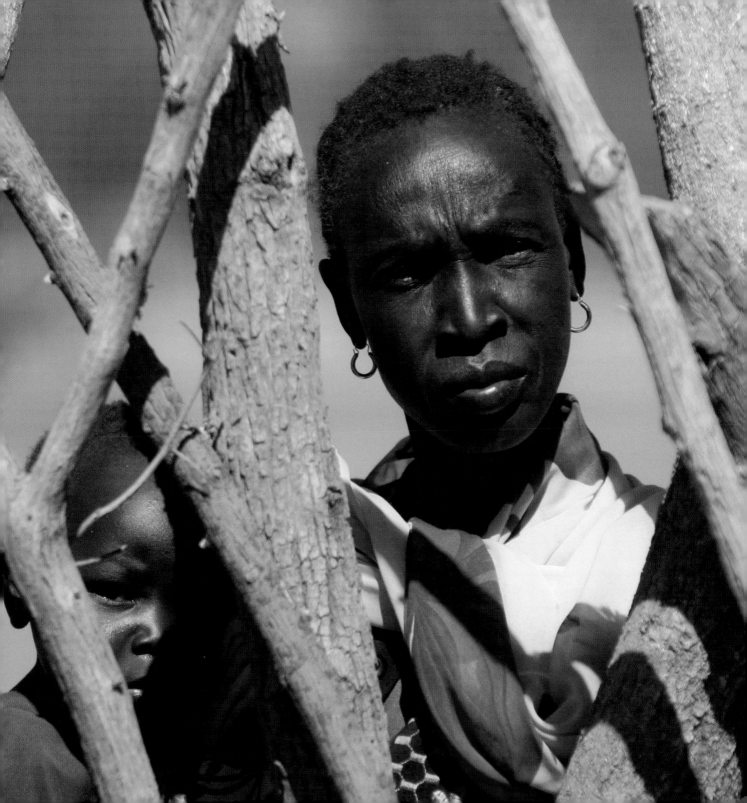

MARY was abducted by the government and held as a slave for seven years. Late one night, she escaped and took her newborn baby girl and her two-year-old to the desert. The NIF (National Islamic Front) chased her down on horseback and cornered her into a bush. Then they proceeded to set the bush on fire and burned her children alive in her arms. Mary was left for dead, but she managed to roll out of the bush and survive the fire. She was found several days later and was taken to be cared for by Christian missionaries.

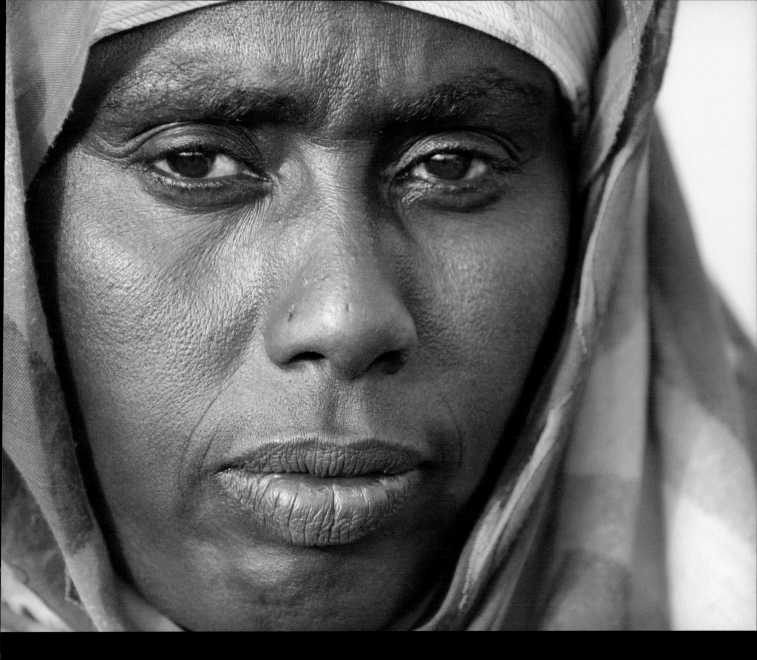

In March of 2008, I found M A H K A living under a tree with her daughter. She is a Muslim whose village had recently been attacked. I asked her why her family was attacked, and she pinched the skin on her left arm and said, "Because I am black."

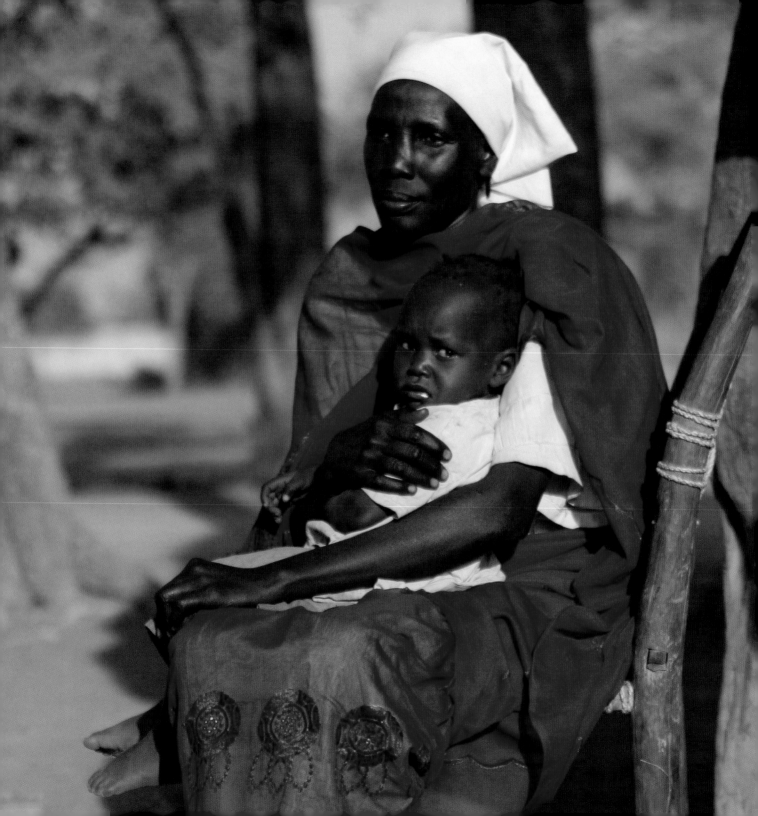

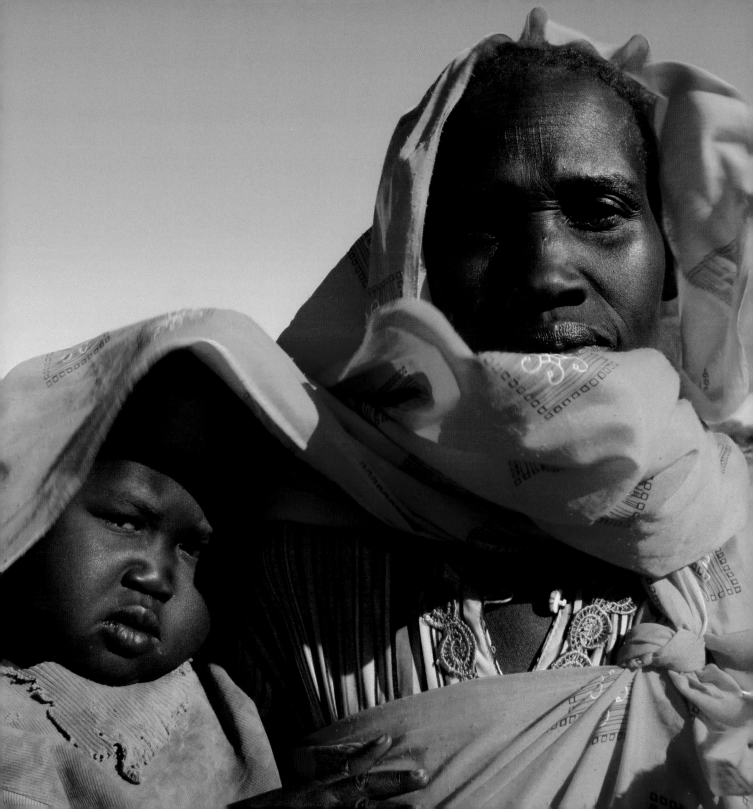

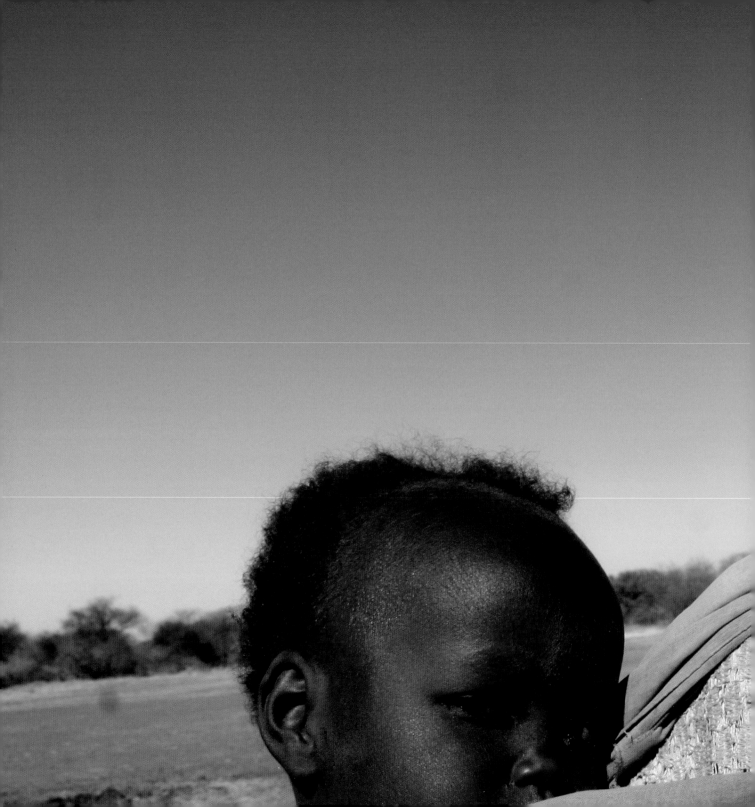

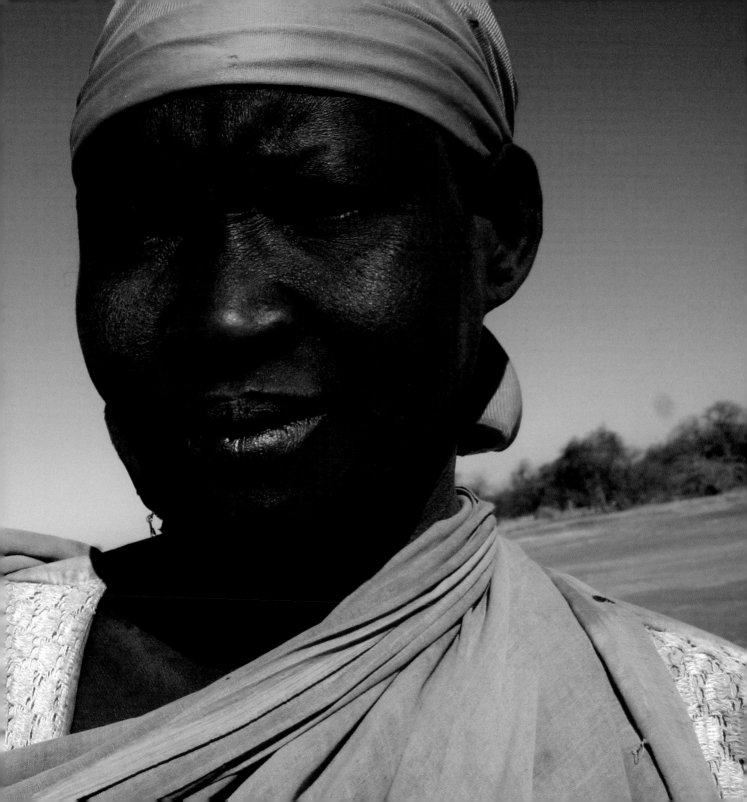

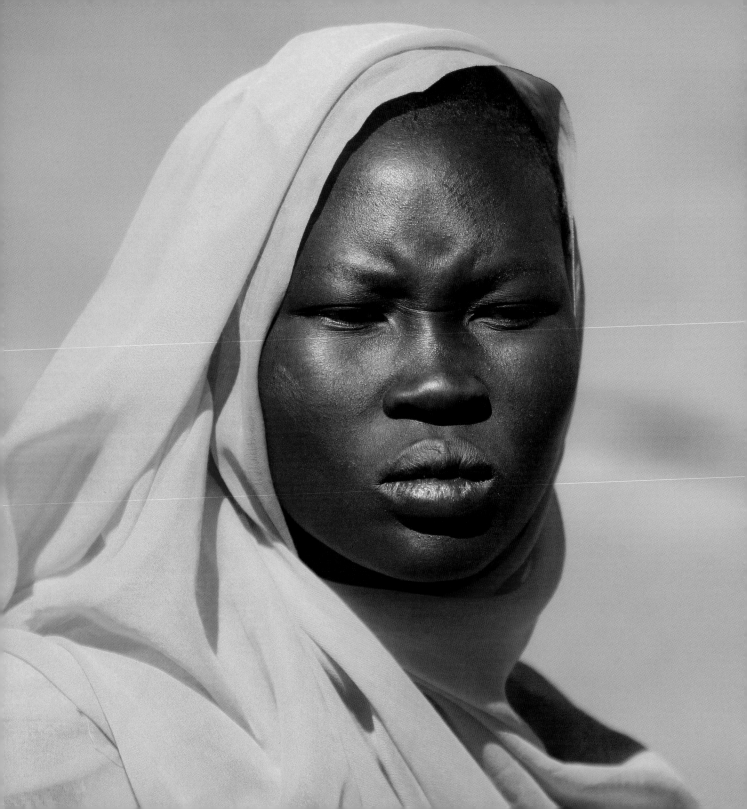

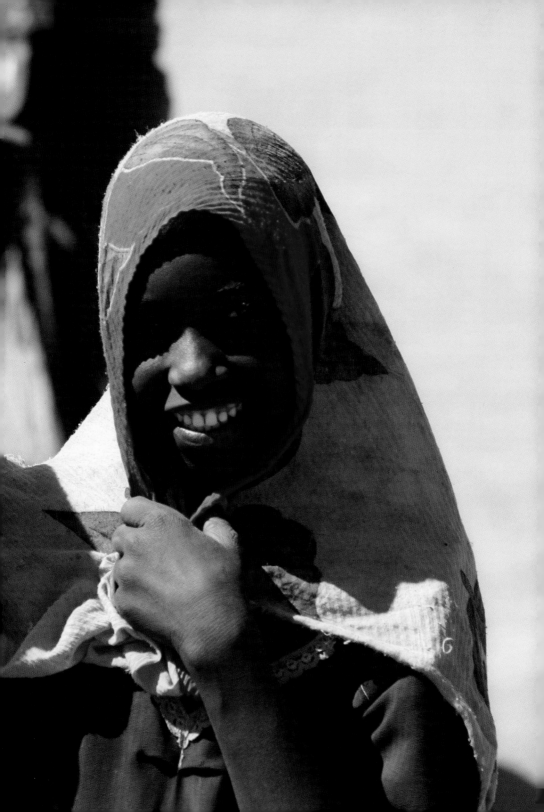

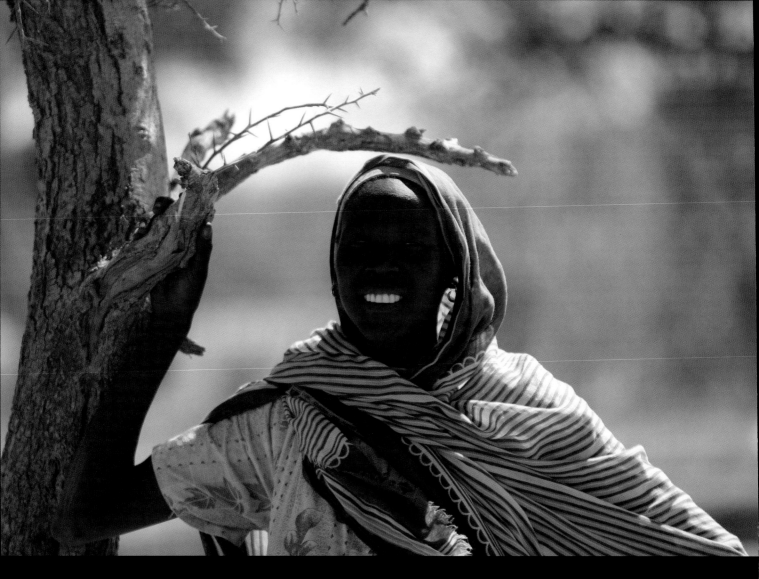

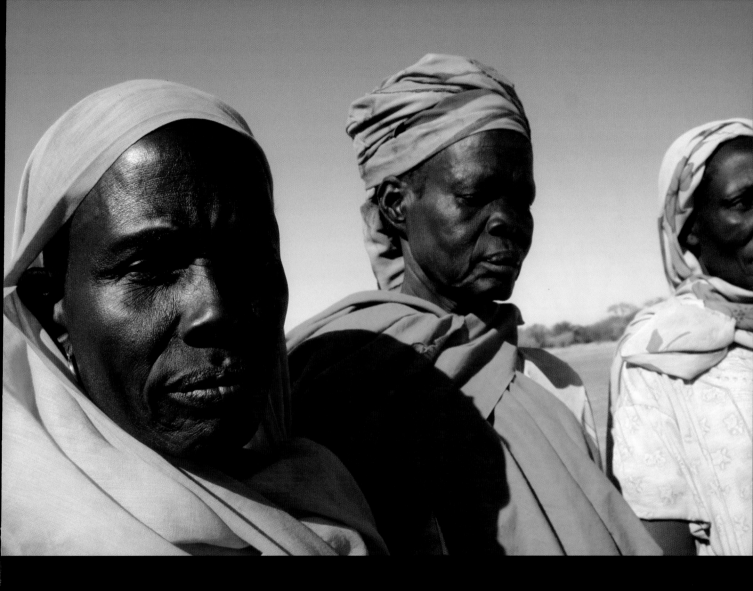

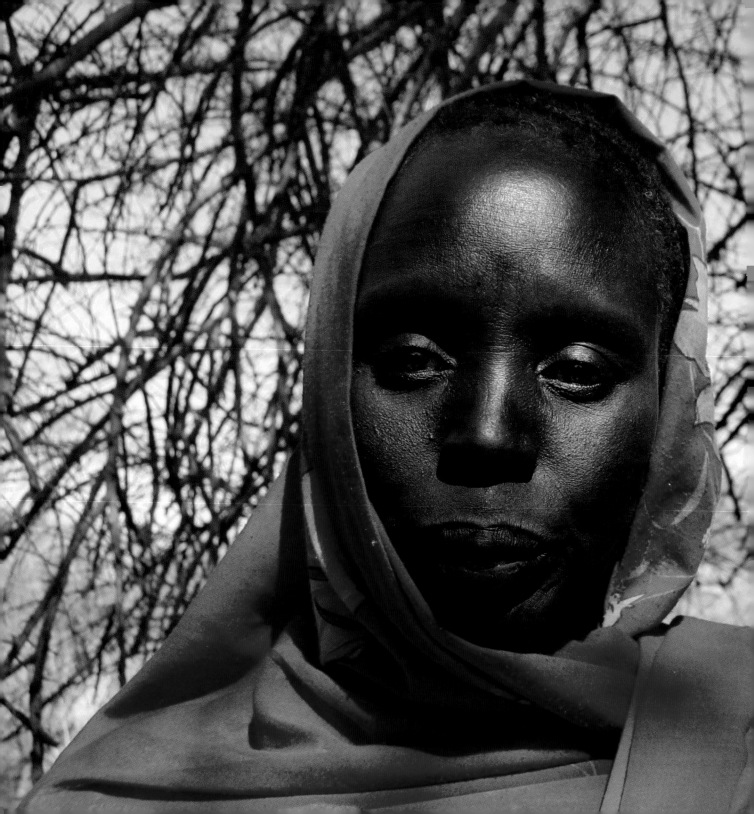

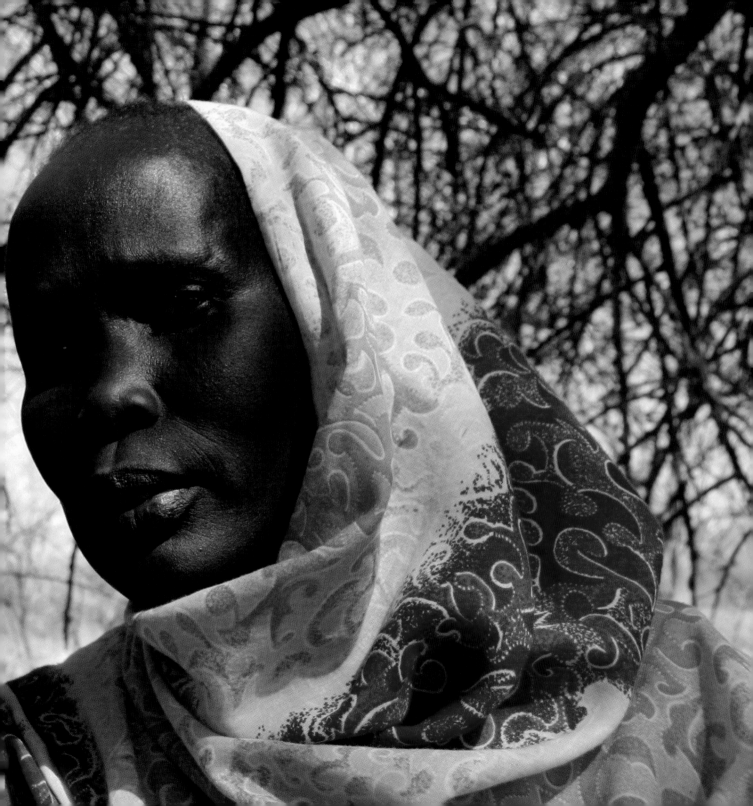

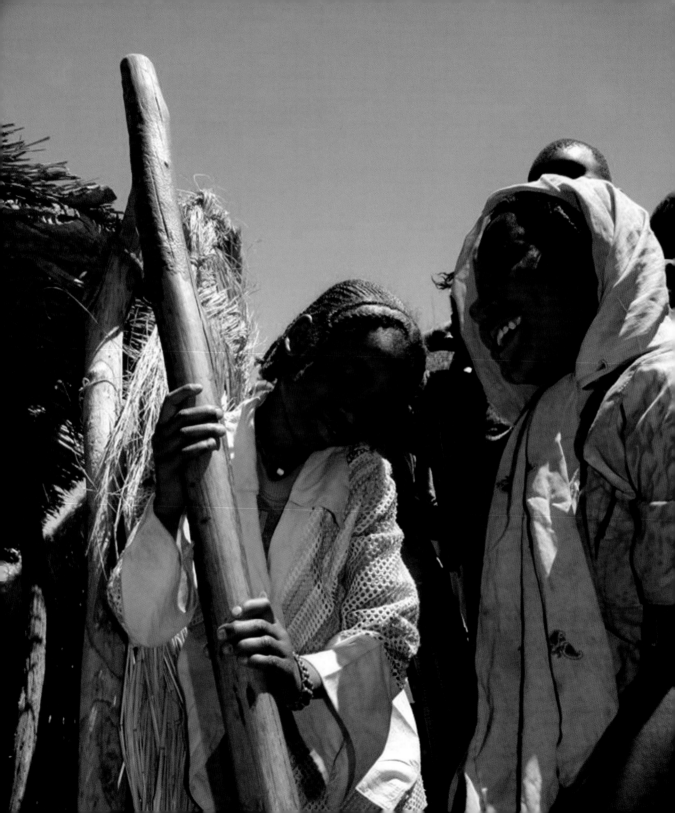

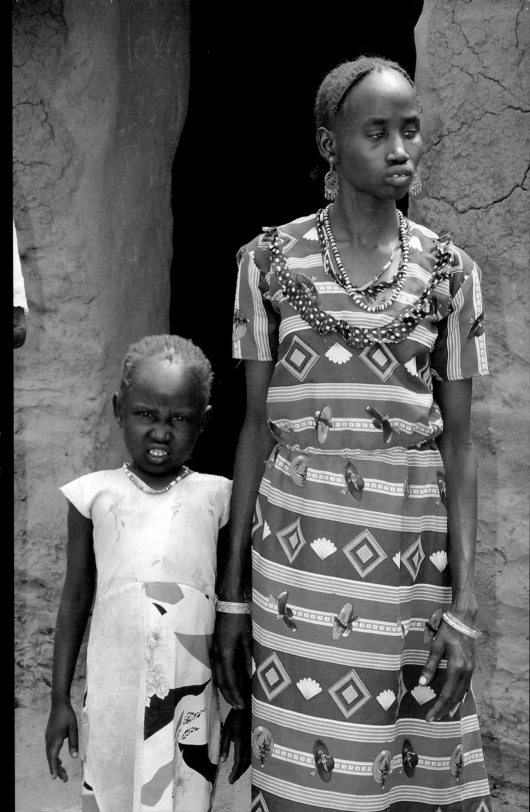

(left) Refugee girls prepare dinner.

(right) L E A H ' S village was raided by radical Islamic forces when she was nine years old. Many people were able to escape. However, because Leah was blind, she was easily captured during the raid. The soldiers gang raped her, and she became pregnant with her daughter (pictured beside her). Today she and her daughter have started a new life together, and Leah is thankful to have another pair of eyes looking out for her.

SCHOOL LIFE FOR THE ORPHANS OF SUDAN

"A child without a mother is like a fish in shallow water."
AFRICAN PROVERB

THE WAR HAS LEFT BEHIND THOUSANDS OF ORPHANS, and there are very few schools to educate these children. The schools that do exist consist of one or two huts built and funded by NGOs (Non Government Organizations). There are no textbooks for the children and few trained teachers. The photographs on the following pages are of an orphanage in southeastern Sudan that was started by James Lual.

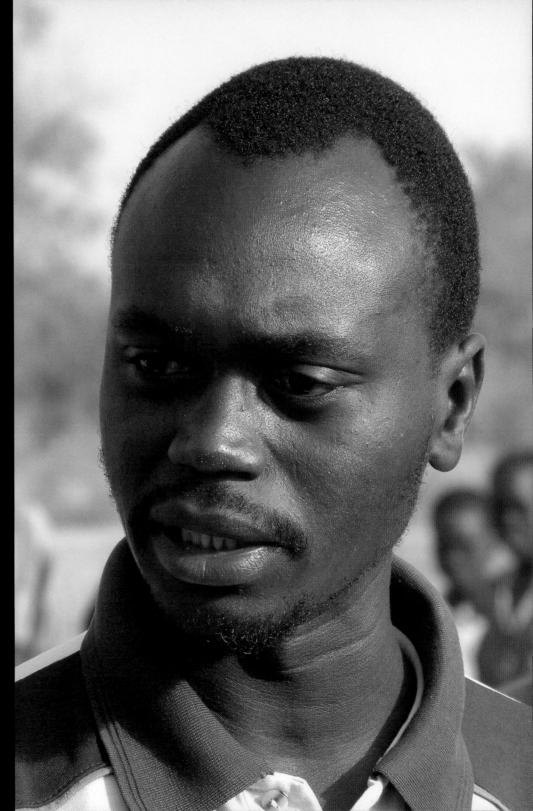

JAMES LUAL, a former Lost Boy, turned down a free ticket to the U.S. in order to return to his home village in Sudan to build an orphanage. Hundreds of children lost both of their parents in the fighting, and they were left to roam alone in the bush. The orphans lived off of wild berries and slept alone in the trees in order to find protection from the hyenas and other wild animals. James began to gather the children, daily, to teach them and offer them one meal a day. With the help of Make Way Partners Ministry, he was able to build more huts and provide education and food for more orphans. He is now working with partners to build safe dorms to provide beds and protection for the children at night.

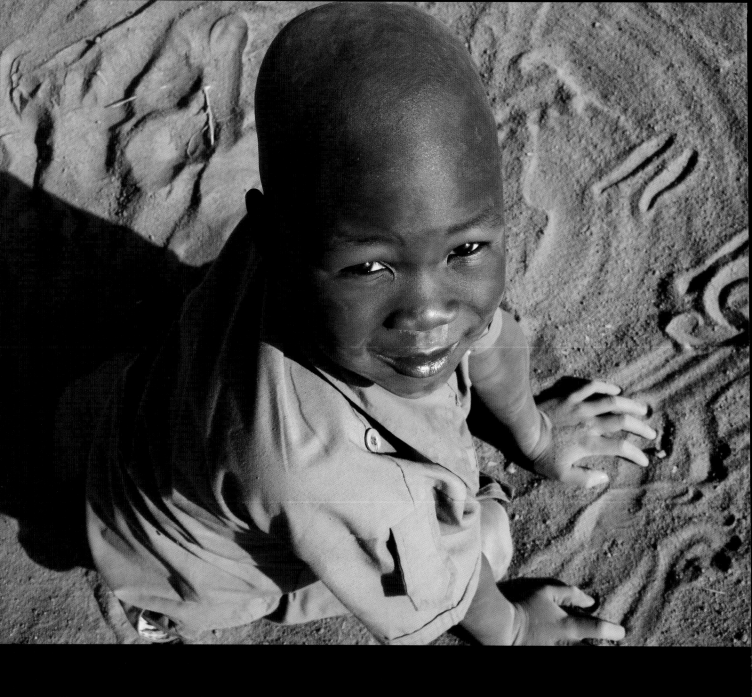

There is no paper for the students, so the orphans use the sand to practice writing their letters and numbers.

(right) An orphan girl practices her writing in the sand.

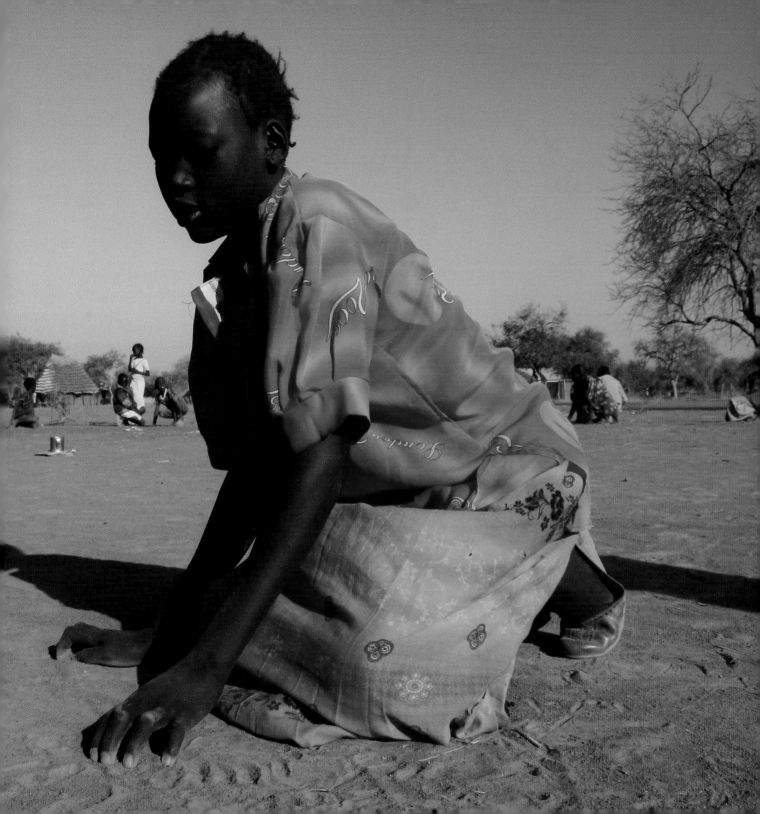

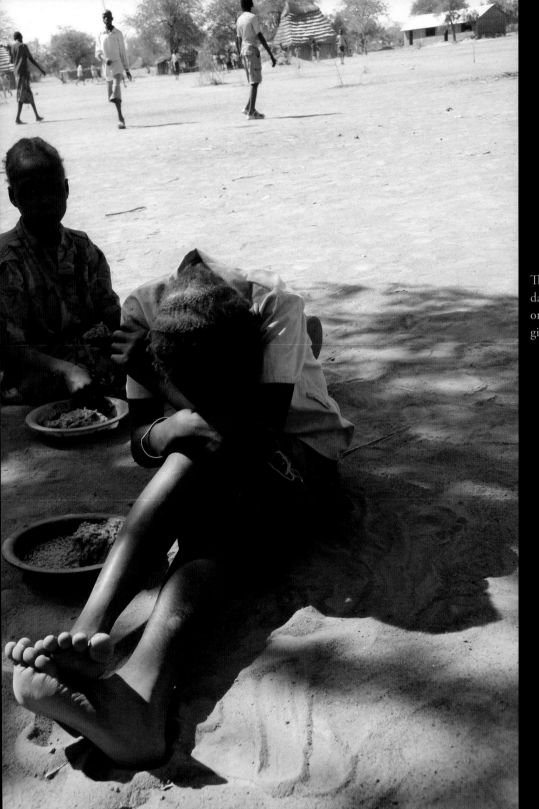

The orphans are given one meal a day. Grateful that she has at least one meal, this young, Christian girl pauses to thank God.

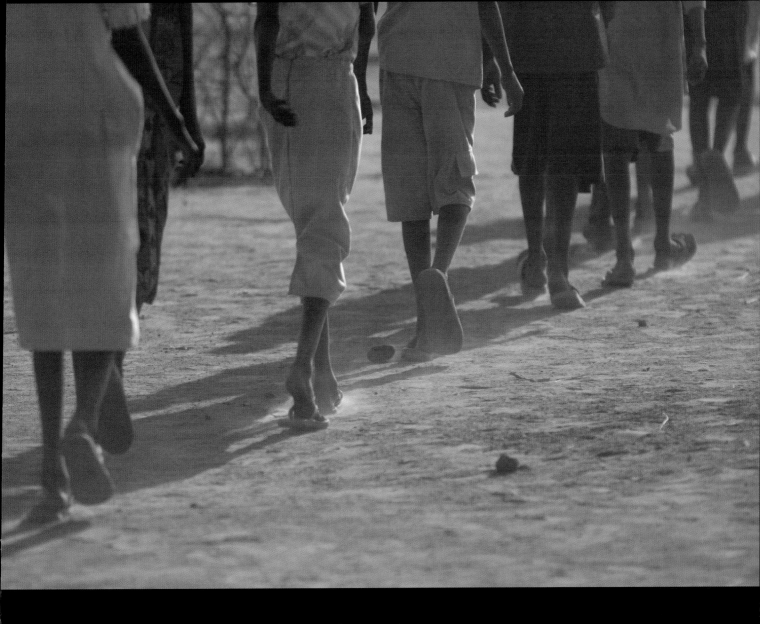

Orphans get up early in the morning and walk for several miles to school.

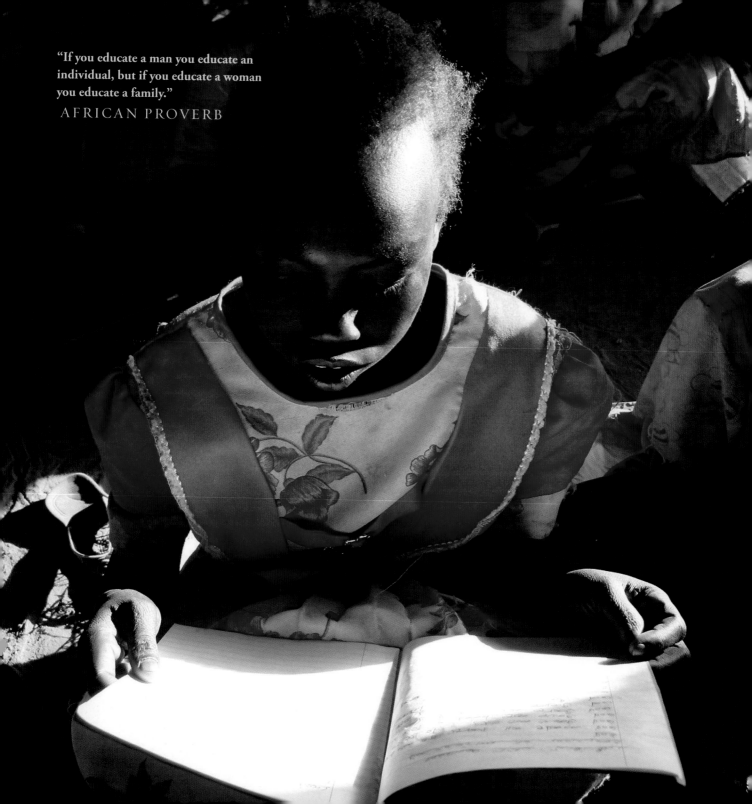

"If you educate a man you educate an individual, but if you educate a woman you educate a family."

AFRICAN PROVERB

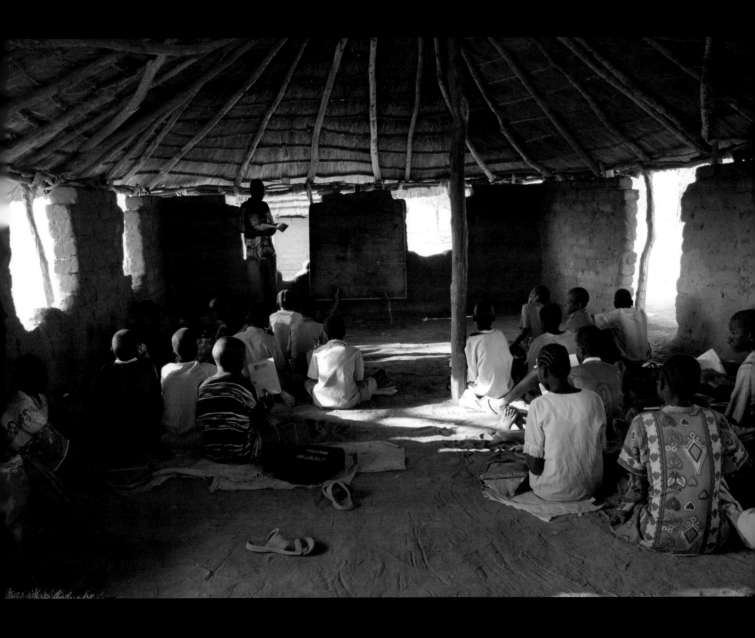

(above) A Sudanese classroom

65

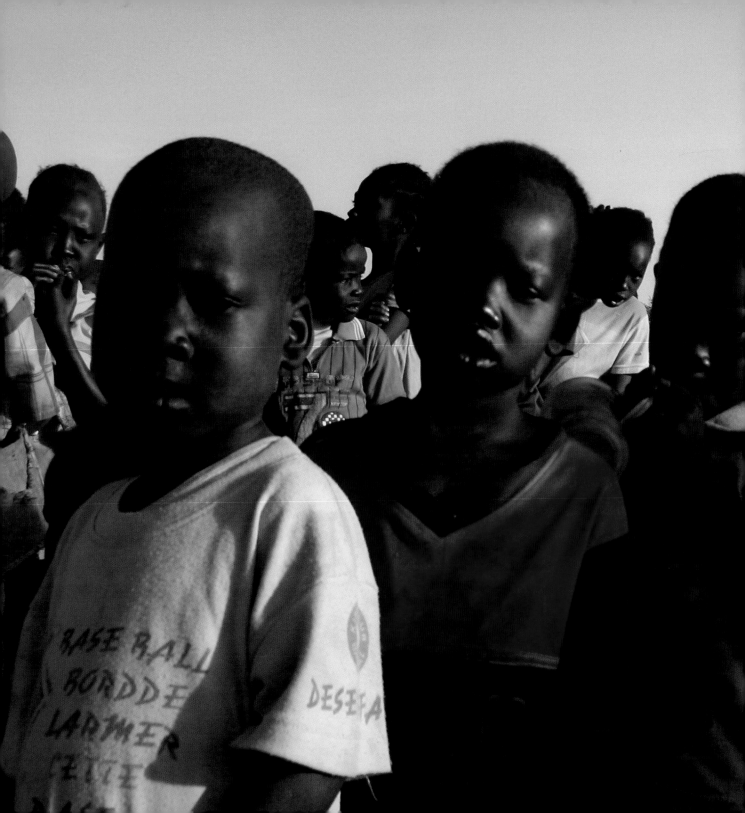

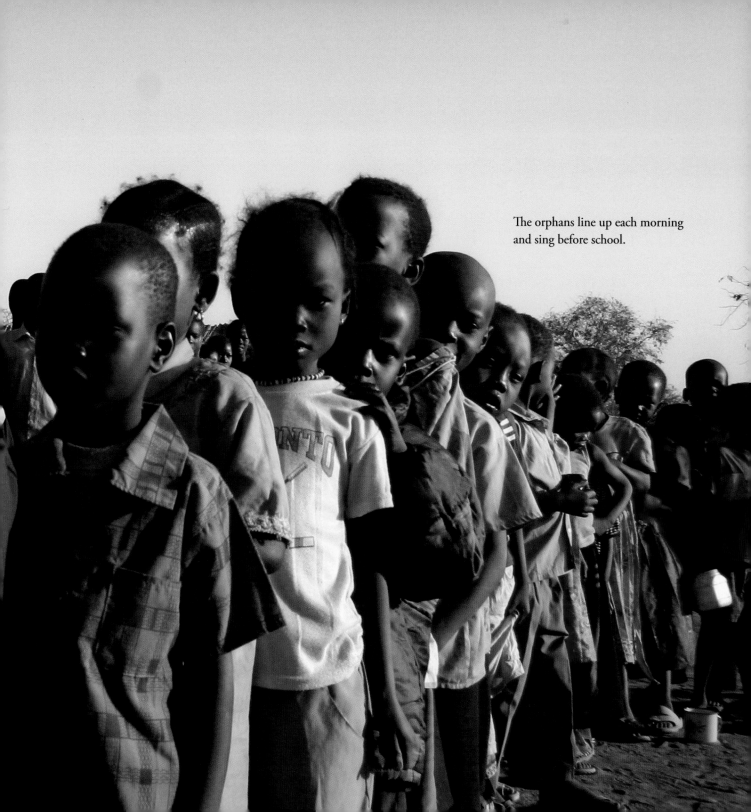

The orphans line up each morning
and sing before school.

CHILDREN AT PLAY

PHOTOGRAPHERS OFTEN RETURN FROM AFRICA with hundreds of images that reflect poverty and oppression. These images need to be seen because they evoke compassion, but there is another side to the Sudanese children. The war in Sudan does leave behind thousands of orphans, but even in the midst of war, the Sudanese children continue to play and laugh. Like many children in the world, they love to put on their best pose and look for every opportunity to show off in front of the camera. Their joyful spirit reminds us that even in the midst of tragedy, the children have not lost hope.

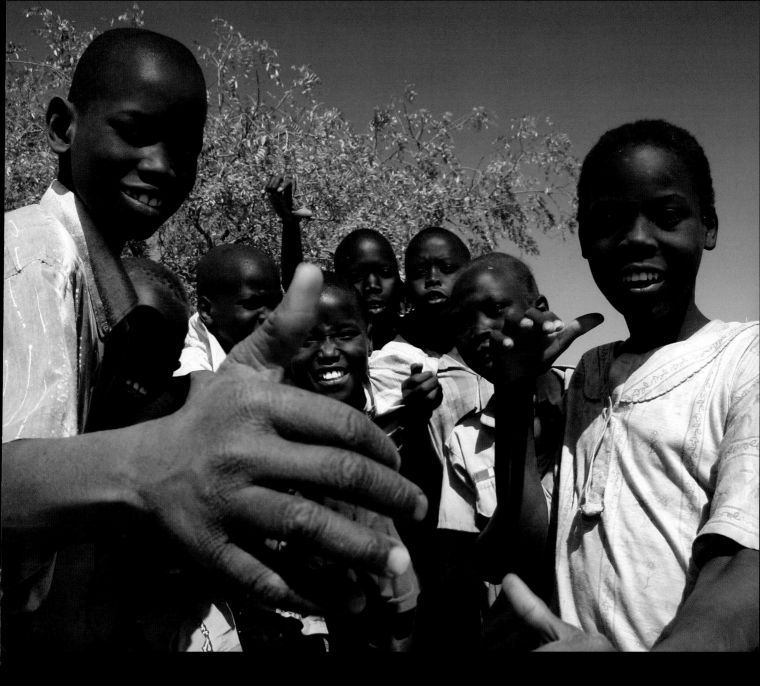

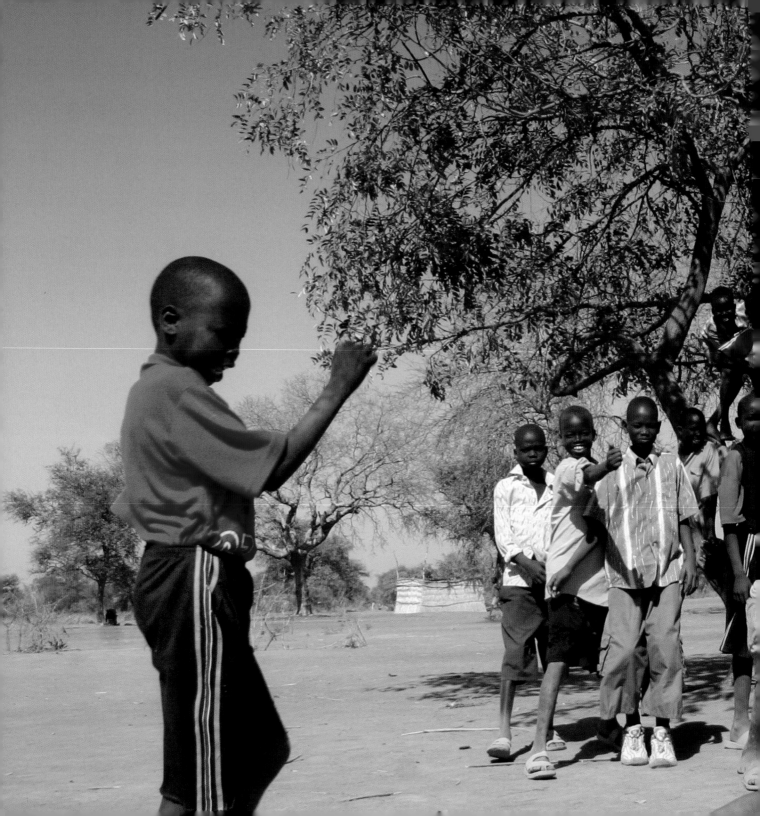

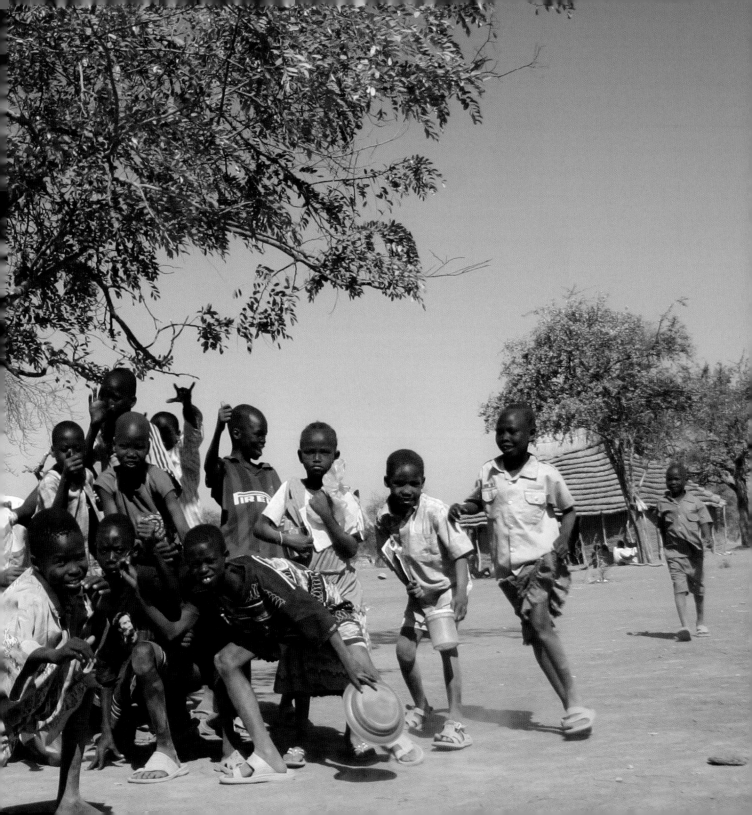

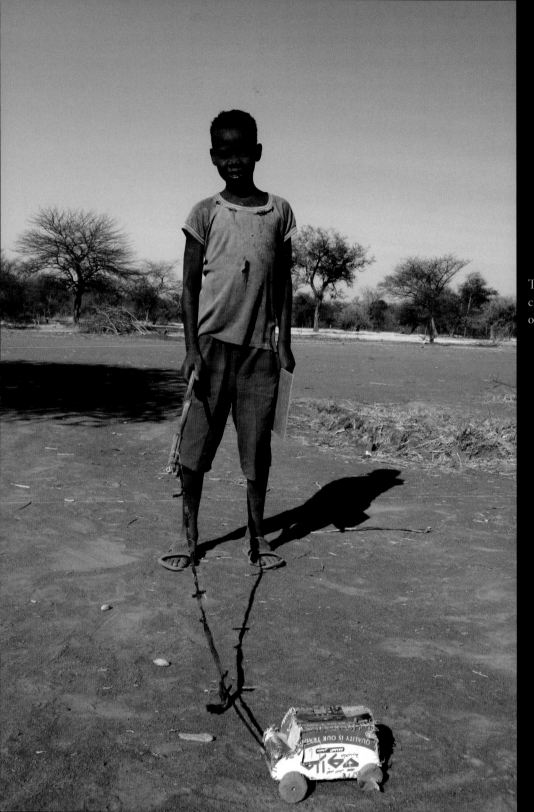

There are no toys, so
creative and build th
old cardboard and w

A piece of iron would be trash in many homes, but to this boy, it is his only source of entertainment.

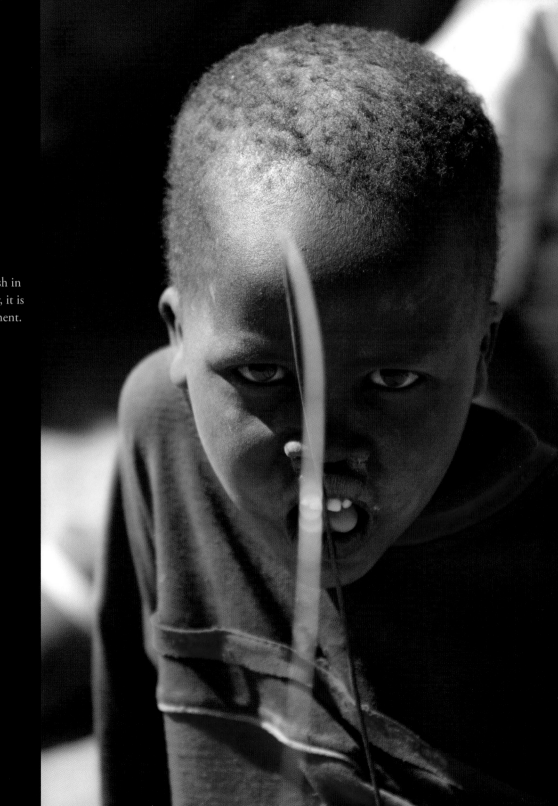

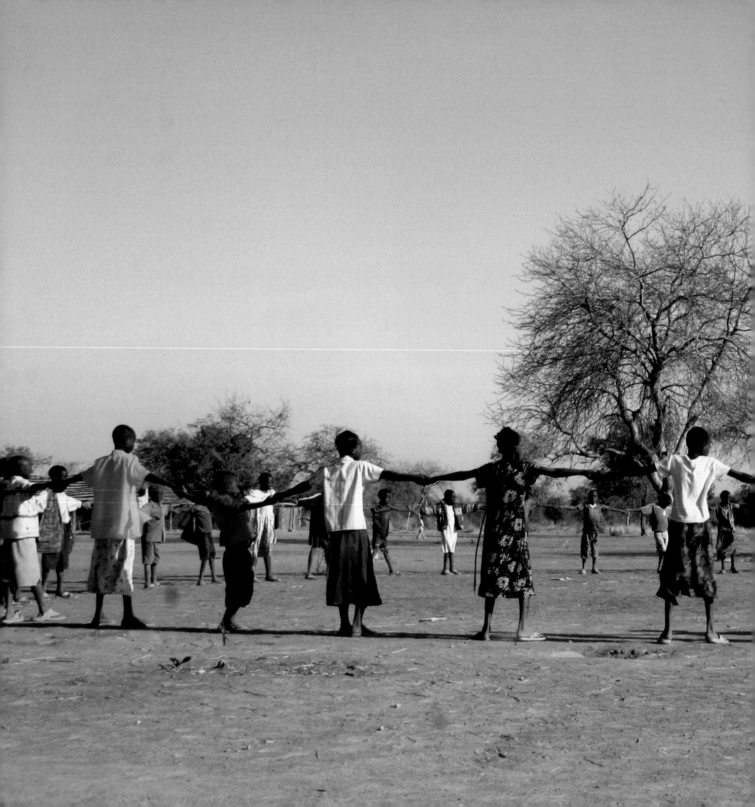

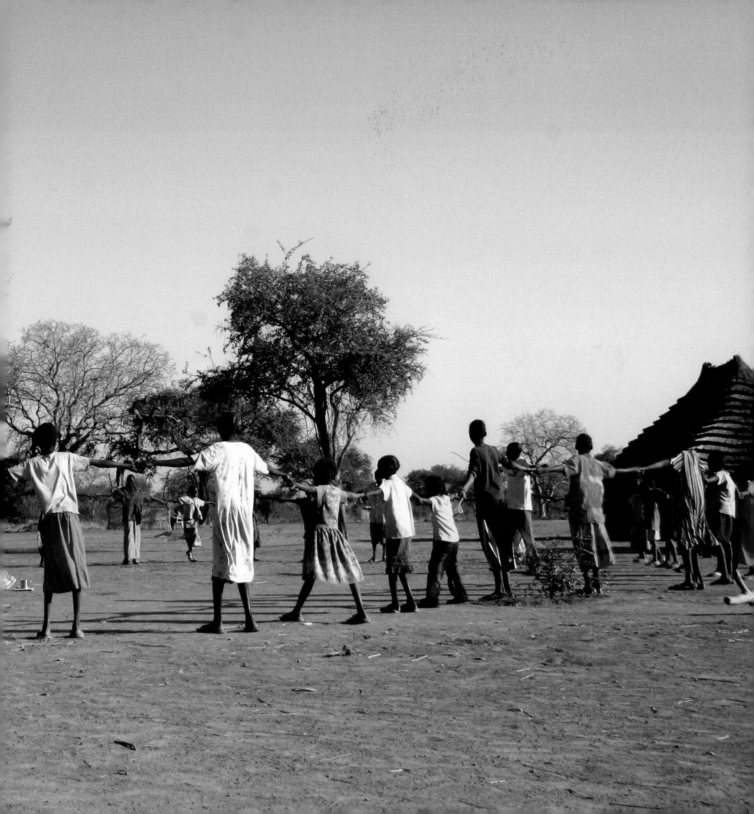

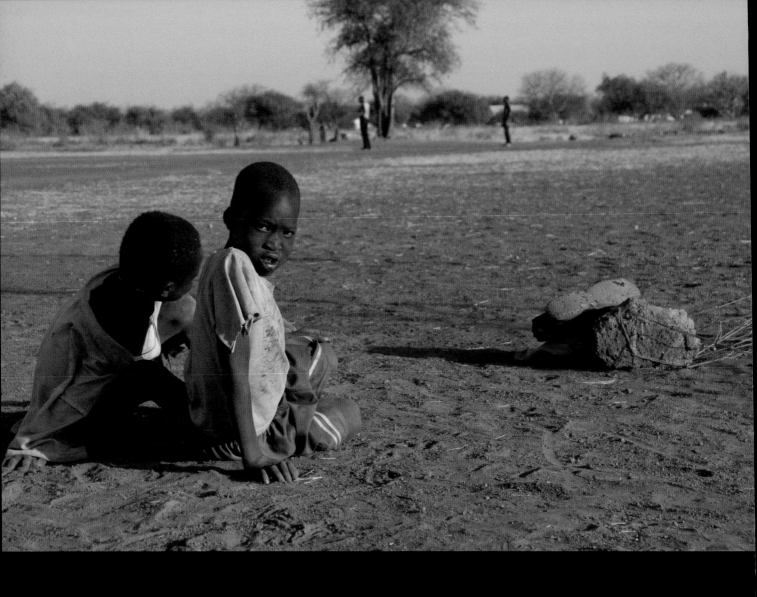

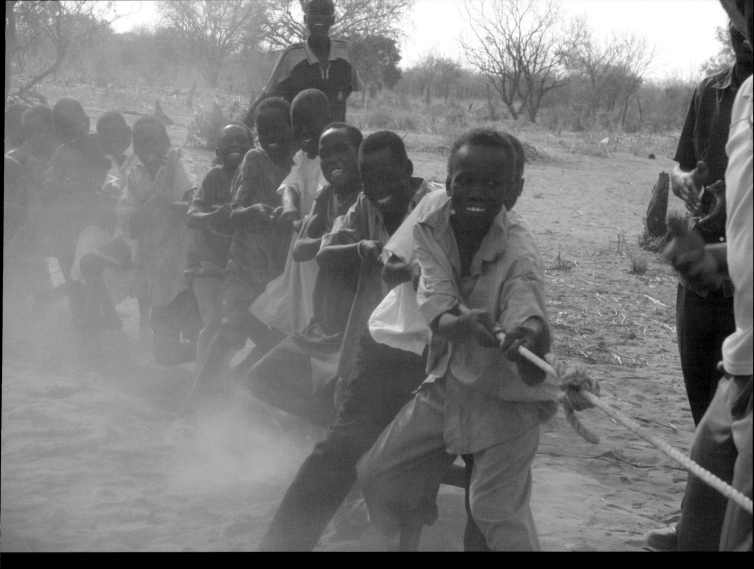

(above) Playing tug of "peace." No war here. The adults changed the name to teach the children to fight for peace and not war.

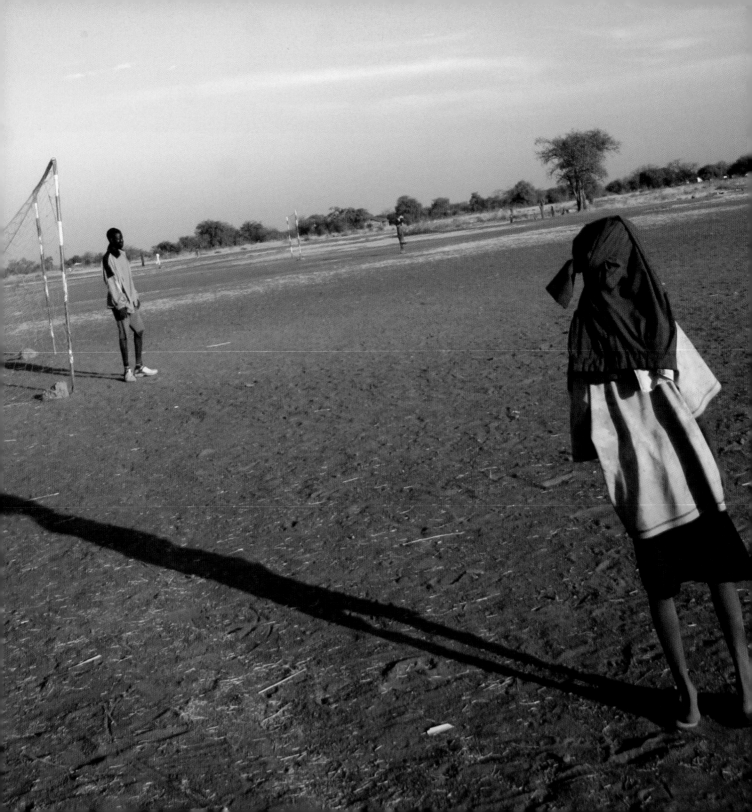

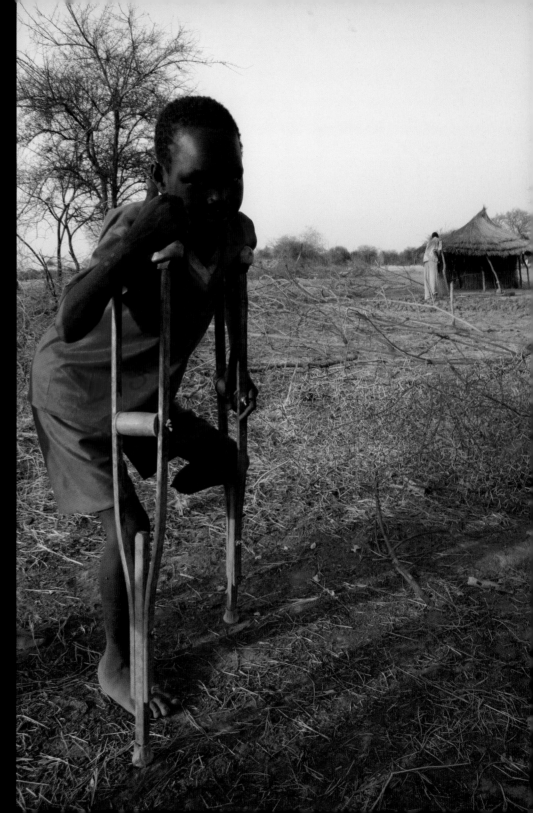

(left) Sometimes the boys are not old enough or big enough to play, so they settle for just watching.

(right) Genocide has taken thousands of lives, but it has not taken the children's hope.

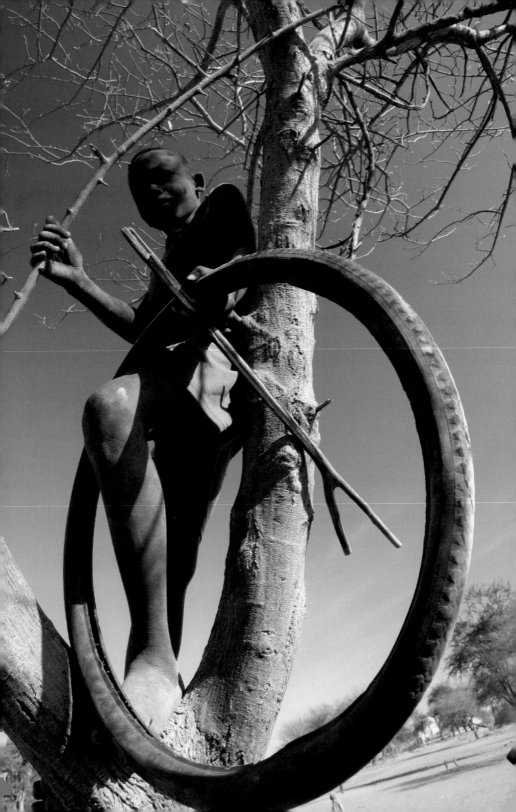

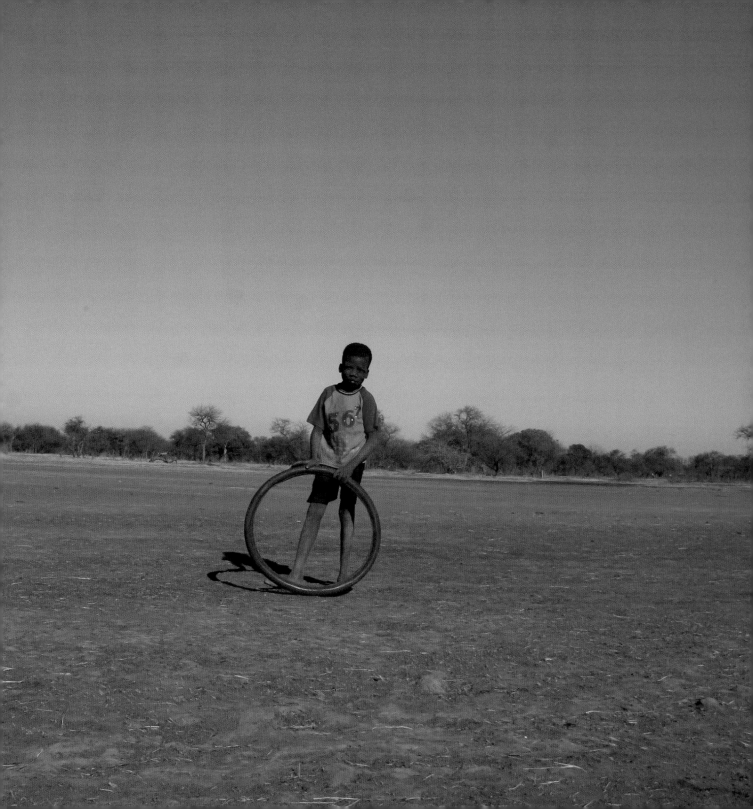

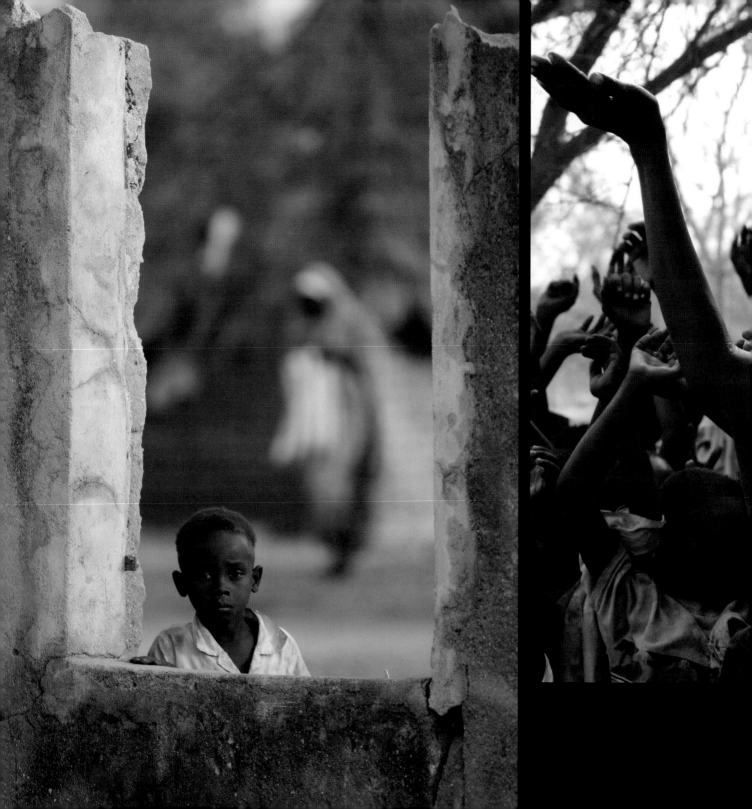

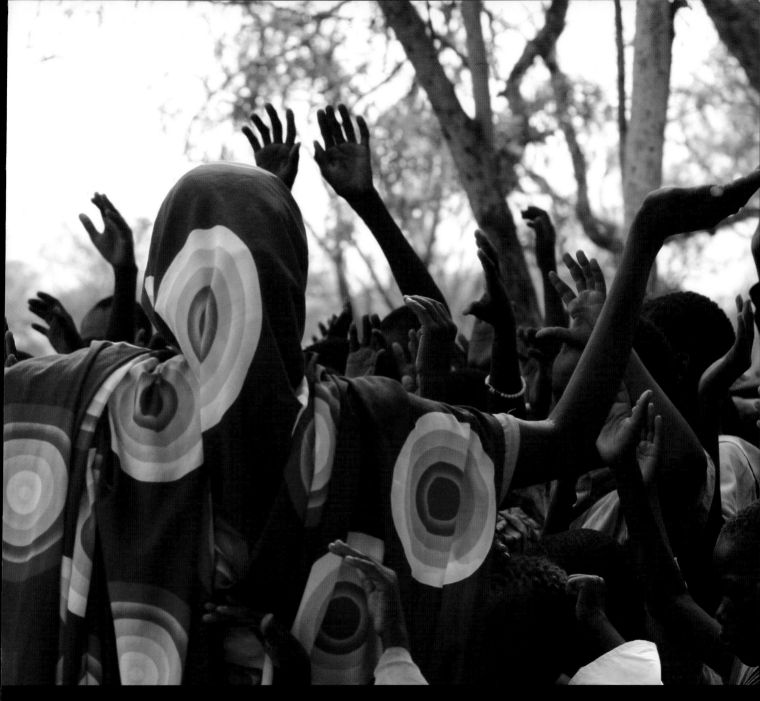

(left) A young boy among the ruins of a building that was destroyed during the bombing.

(above) A woman in Darfur leading the children in prayer.

SURVIVAL

ODATTI, pictured on the right, shares his story. "The soldiers came in the middle of the night. They came from Malakal. Everybody ran. Some into the bush. Others ran into the river. Many drowned. They shot everywhere. They killed blind old ladies who could not run away."

HASSEN DOES NOT REMEMBER HIS REAL NAME, but he does remember being abducted by the Arab nomadic militia at the age of eight. Hassen tells his story. "When the soldiers came, there was a lot of bombing and screaming. People were running in many different directions, especially the children. I ran into the river with my friends. The Arabs caught me and one of my friends and took us and shut us up in camel baskets and took us away. They forced me to become a Muslim, and they killed the other boy and took his blood and skin for magic. Then they sold me to a family, where I stayed for nearly 15 years. The family cut the tendons in my hands and feet to keep me from running away."

ELIZABETH was attacked by government troops and tells her story. "My husband was killed right away. I ran with the kids. Two of them drowned in the river, and the other two, I don't even know where they are. You tried to grab one child here and there, but you could only do so much."

"We started running," said another woman. "They kidnapped my older daughter and my husband. I came here by myself. One of the raiders came and talked nicely to my sister, politely at first, and tried to have intercourse with her. When she refused, he raped her and took her with them. I don't know if she is still alive."

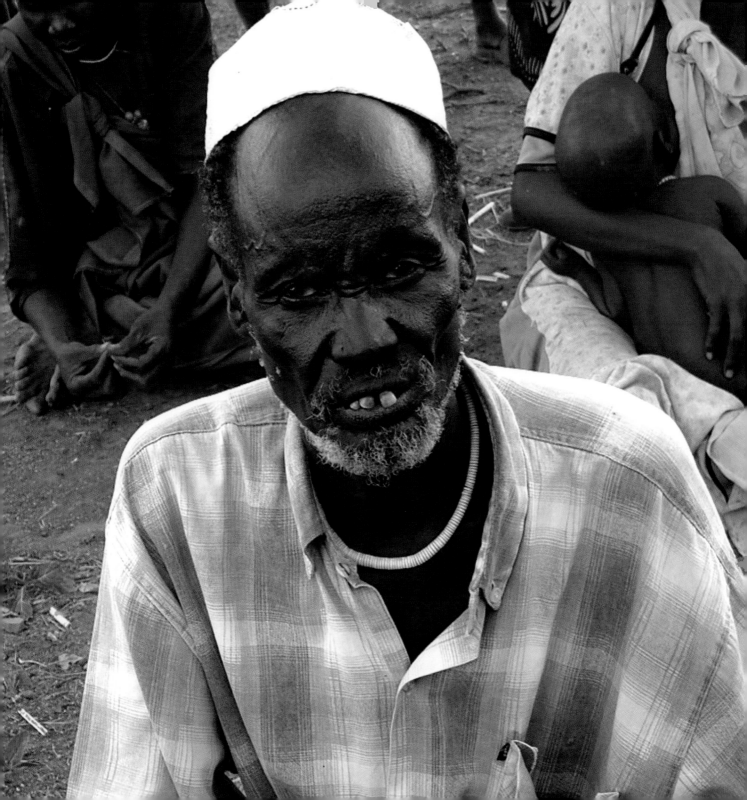

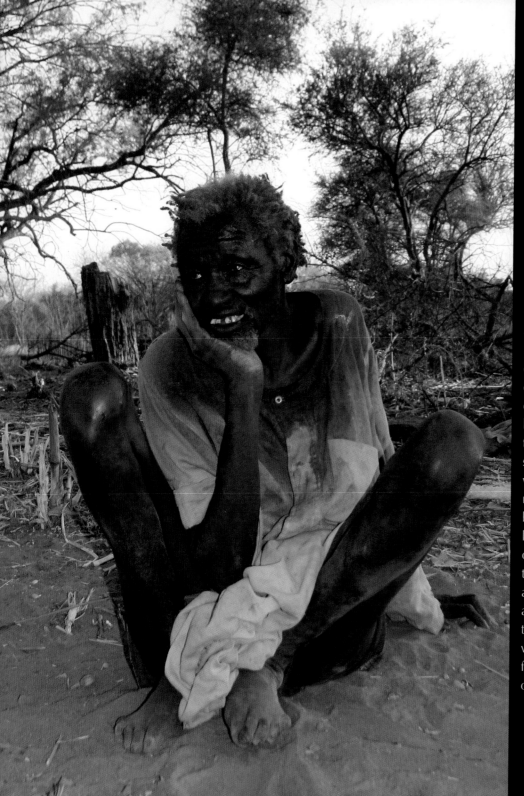

AMET sits with a slight smile as he revisits fond memories of his wife and children. He and his family used to live peacefully in a small hut in the city of Dan. The government came and took his wife and children and told them to board a train that was going to bring them to safety in the south. His wife and children waved goodbye, and the next thing he saw was a huge ball of fire. The government lured all of the Sudanese onto the train only to burn them alive. He now lives alone in Darfur, with neither a home nor a family. After the interview, all he asked for was a pair of pants. Joshua, from Watermelon Ministries, offered the man his extra pair.

TITO'S heart is as big as his smile. His disposition is soft, but his actions are those of a warrior. He once fought for the southern Sudanese army, where he protected hundreds of innocent people from being killed. Later, he was captured by the NIF and trained to fight and kill his own people. Late one night Tito escaped and walked for days to return to the south to protect his people again. After years of service, he was offered a free ticket to Australia to take his family and start over with a peaceful life. He turned it down and returned to Sudan to serve as a pastor. Today, he travels throughout Darfur and other war torn areas, befriending and serving the Muslim and Christian refugees.

FAMINE

"It is not just climatic conditions that are causing the famine in Sudan. It is a crisis brought about by the National Islamic Front. The war they wage includes using deprivation of food, deprivation of human rights, as well as their military campaign."
RELIEF WORKER IN SUDAN

"OFFICIALS ESTIMATE THAT AT LEAST TWELVE PEOPLE A DAY DIE FROM STARVATION. Other reports say that the death rate is more than 100 a day" (CNN.com). Relief organizations have tried to bring food to the refugees, but moving the food overland is difficult. Infrastructure has been destroyed by drought and war, and in some areas, it can take nearly an hour to drive ten miles. In addition, the increased levels of insecurity in recent months, combined with attacks on aid workers, have left refugees beyond the reach of humanitarian aid.

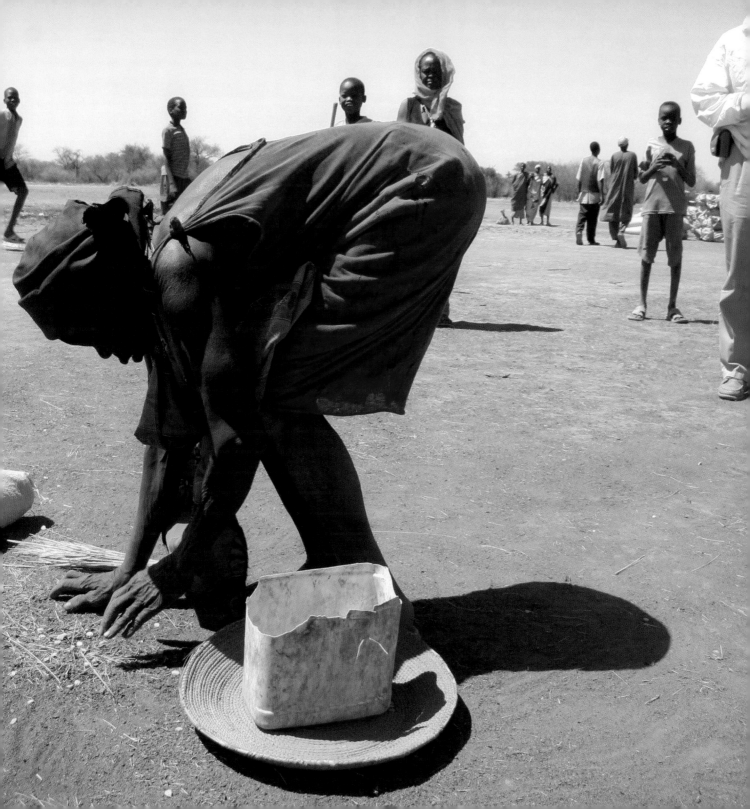

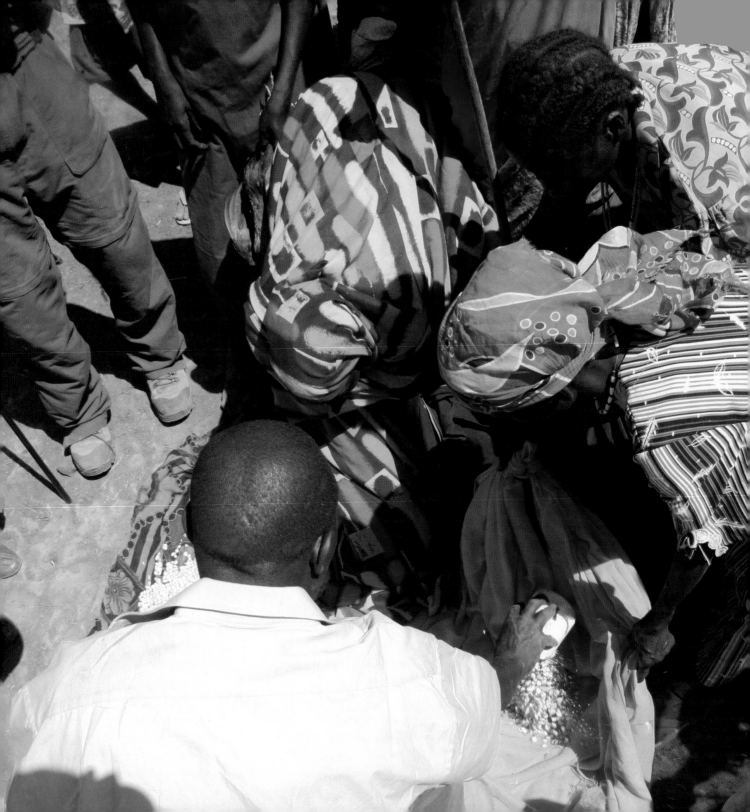

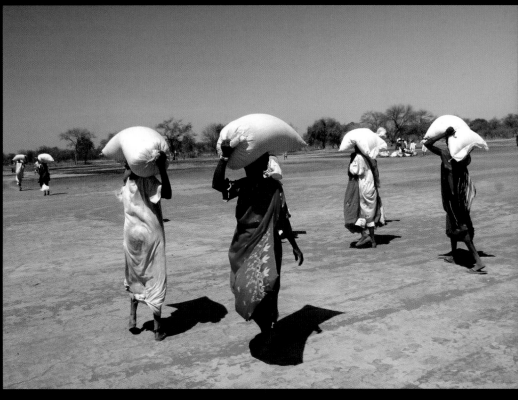

(above) The women carry the food home for their families.

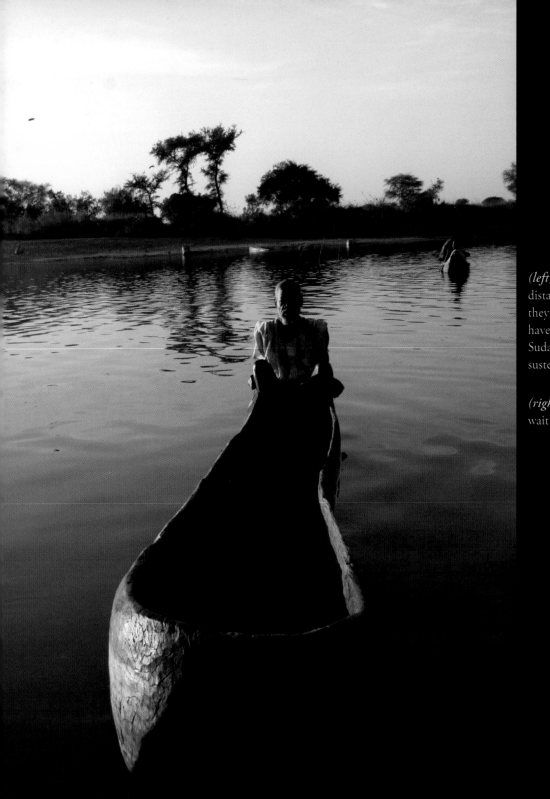

(left) The men travel for long distances to get to a river where they can fish. Since most cattle have been slaughtered, the Sudanese depend on fish for sustenance during the famine.

(right) Muslim men line up and wait for the food to be distributed.

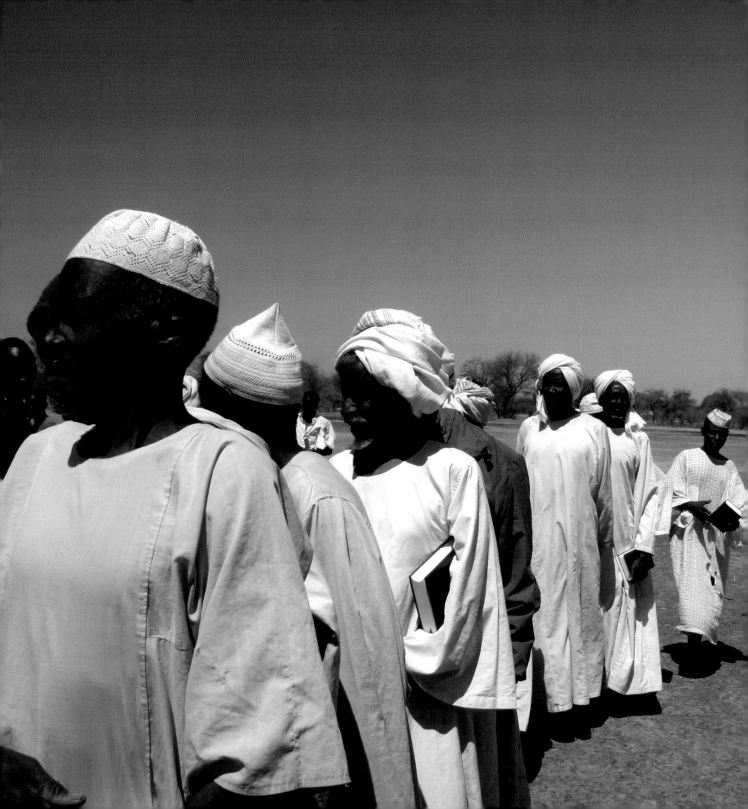

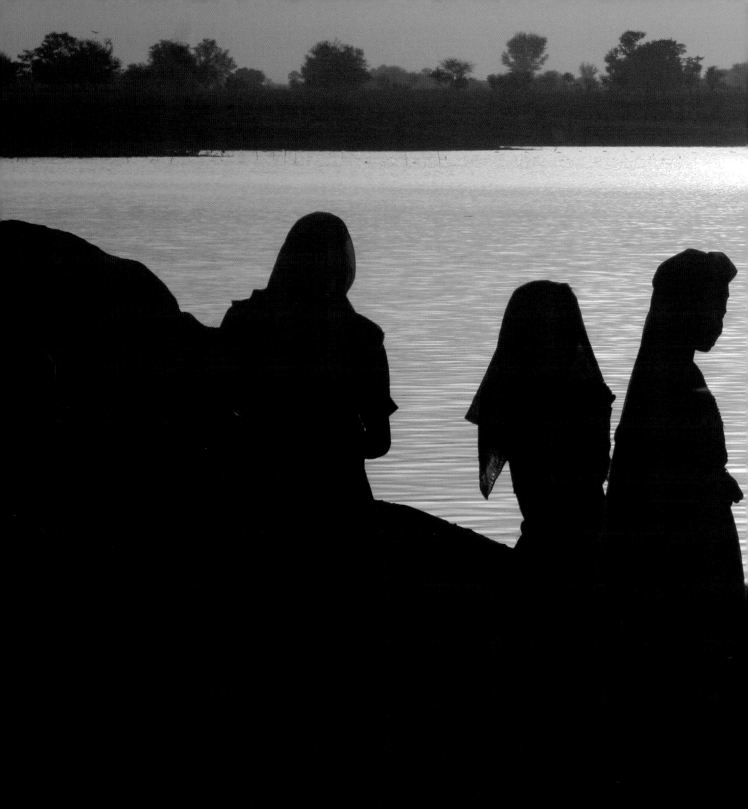

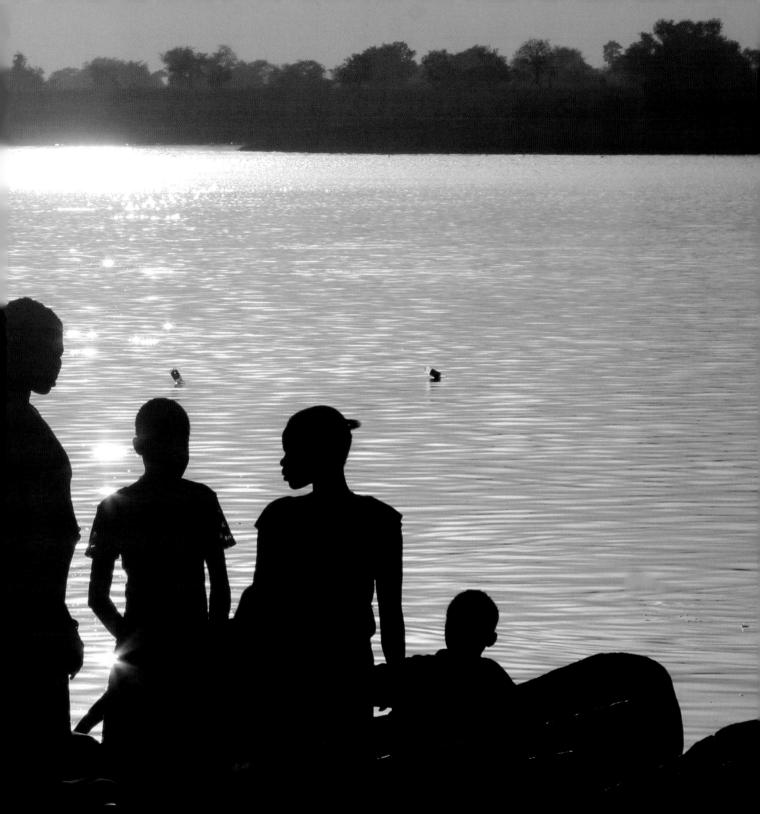

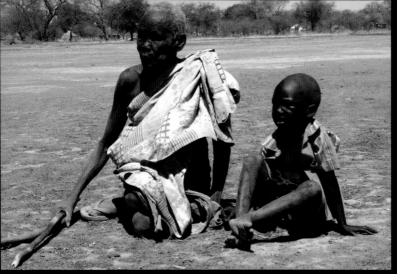

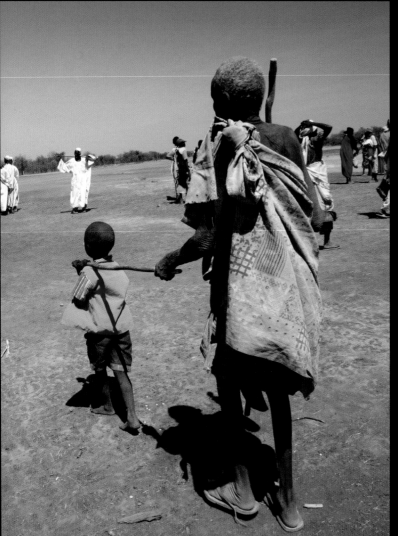

(left) A grandfather and his grandson wait for their portion of the food distributed from the relief plane.

After receiving the grain, the boy leads his blind grandfather home.

(right) The Dinka Christians dance and sing a thanksgiving song to God for food and medicine after the cargo plane arrived.

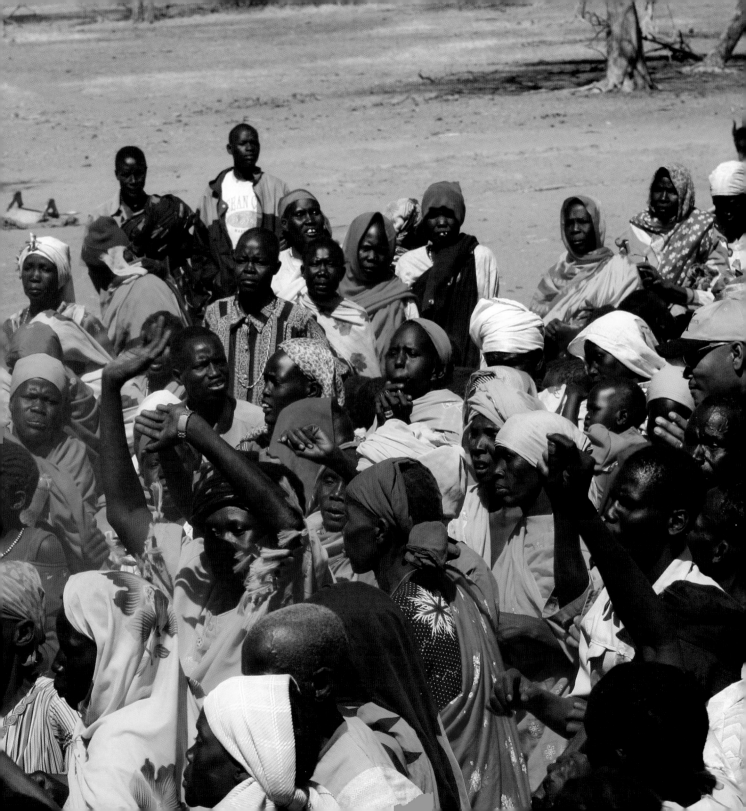

While working on this book at a local coffee shop, I received an email from one of my former English students wanting my insight into her poem about Sudan. It gave me hope in the next generation's ability to empathize with and fight to speak out for the Sudanese.

A DARK & LONELY PLACE

With all hope lost, they close their eyes,

Dreaming of a place where everything is okay,

They try to remember what it was like before,

Before they lost their families,

Before the villages were destroyed,

Before they saw their parents' death,

Before they saw their children leave,

Before the end of the world,

Before fear, before hatred, before tragedy,

When they had water, when they had food,

When they had family and friends,

When they were free,

When there was no reason to be scared,

They dreamed, they hoped, they prayed,

They called out in pain, and shouted to the heavens,

But in the end, no one came,

Their voices were still unheard.

ERIN HUNT

14 years old, Providence Day School

WANT TO HELP SUDAN?

You can contact any of these organizations to help them in their efforts to serve the Sudanese.

AFRICAN LEADERSHIP

African Leadership is a Christian education organization that trains local pastors and church leaders and funds relief and development projects in their communities. They help to meet spiritual needs by providing theological training to pastors and church leaders in Africa who cannot afford to attend seminary or Bible College, and therefore are untrained and unprepared for their leadership roles in the church. They also provide continuing education opportunities for these students in topics such as HIV/AIDS, Islam, financial stewardship, sports outreach and child protection. African Leadership also helps to meet physical needs by funding relief and development programs in the communities it serves. They work through their network of national directors, trained pastors and church leaders and ministry partners to empower community leaders with the necessary resources to help their fellow Africans. Their work includes such areas as emergency relief, children's services (schools, orphanages, medical clinics and sports), HIV/AIDS prevention and care, job and life skills training, and refugee assistance.

CONTACT INFORMATION:

African Leadership

P.O. Box 682444

Franklin, TN 37046-8803

Phone: (615) 595-8238

Fax: (615) 595-7906

E-mail: info@africanleadership.org

Websites: www.africanleadership.org

www.mochaclub.org

PERSECUTION PROJECT FOUNDATION

Persecution Project Foundation was founded in 1998 to equip and mobilize Christians in America to take action in support of the persecuted church in Africa. To that end, they collect and disseminate information about incidences of Christian persecution in Africa, with particular emphasis on Sudan. Their ministries include Radio PEACE (Sudan's premier Christian radio station), pastoral training programs, schools/orphanages, as well as food, shelter and medical relief. They also extend their outreach to thousands of Darfur refugees by providing them with medical treatment and fresh water from wells that they are drilling. Their desire is to bring the gospel message of Jesus Christ to the people of Africa, while simultaneously ministering to their physical needs.

CONTACT INFORMATION:
Website: www.persecutionproject.org
P.O. Box 1327 | Culpepper, VA 22701
Phone: (540) 829-5353
** (888) 201-5245 (toll-free)**
** (540) 829-5357 (fax)**
Brad Phillips, President
info@persecutionproject.org

BLOOD: WATER MISSION

This is a non-profit organization founded by the members of the multi-platinum, Grammy Award-winning band, Jars of Clay, to address the HIV/AIDS crisis in Africa. They exist to promote clean blood and clean water efforts in Africa, tangibly reducing the impact of the HIV/AIDS pandemic while addressing the underlying issues of poverty, injustice and oppression. Blood:Water Mission is building clean water wells, supporting medical facilities, and focusing on community and worldview transformation, both here in America and in Africa.

Website: www.bloodwatermission.com
Phone: 615-550-4296

CSO

This is a Christian sports ministry that assists in training African pastors to minister to the people of Sudan. CSO provides training, encouragement, and sports equipment for the pastors who serve the Muslims and Christians in Sudan and other parts of Africa.

Website: www.csosports.org
Phone: 704-688-4227

DOCTORS WITHOUT BORDERS

This is an independent international medical humanitarian organization that delivers emergency aid to people affected by armed conflict, epidemics, natural or man-made disasters, or exclusion from health care in more than 70 countries.

Website: www.doctorswithoutborders.org
Phone: 41 (22) 849.84.00

MAKE WAY PARTNERS

This is a Christian agency committed to prevent and combat human trafficking and all forms of modern–day slavery. Their primary ministry focus is with women and children, which are the highest at-risk groups. They offer practical alternatives and assistance to the most vulnerable, while receiving and providing care to those making their way out of slavery. Within The Body of Christ, they build partnerships, to call forth those willing to answer the Biblical call to seek justice on behalf of the oppressed through prayerful intercession, financial support, ministry and mission service.

Website: www.makewaypartners.org
Phone: 205-240-8597

SAMARITANS PURSE

This is a Christian organization that provides desperately needed assistance to victims of natural disaster, war, disease, and famine. As they offer food, water, and temporary shelter, they meet critical needs and give people a chance to rebuild their lives.

Website: www.samaritanspurse.org
Phone: 828-262-1980

SIM (SERVING IN MISSION)

This is a Christian organization that longs to follow Christ's example in loving the whole person, so they are committed to the physical, emotional and spiritual needs of individuals who can then help to transform their societies economically, socially and spiritually. The Sudanese of 2007 are *survivors* coming back to their homeland! SIM is right alongside the poorly equipped but incredibly resilient people *Rebuilding Southern Sudan: Church and Nation*. SIM is looking for godly, gutsy, flexible people to join in God's mission in Sudan.

Website: www.sim.org/sudan
Phone: 704- 588-4300

WATERMELON MINISTRIES

This is a Christian ministry that creates a network of creative people to provide opportunities to speak out for persecuted or impoverished people around the world. The ministry also creates outlets for giving to servants so they can go and minister to the "voiceless" people of the world.

Website: www.watermelonministries.com
Phone: (615) 969-3546

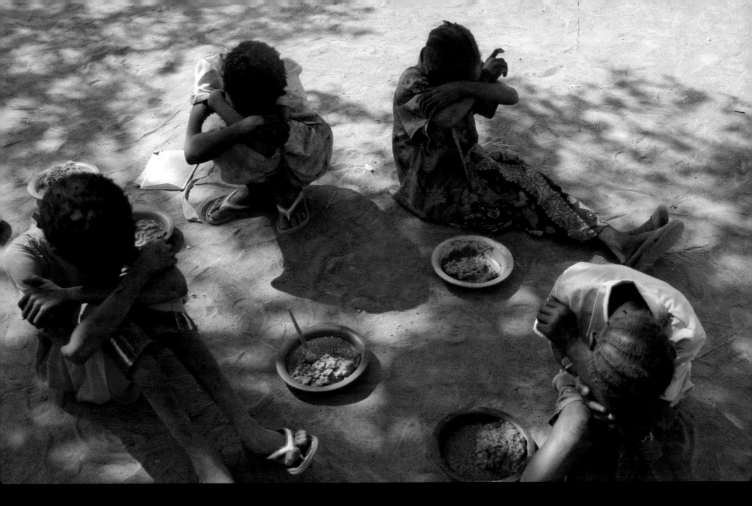

SILENT IMAGES

Silent Images (SI) is a non-profit organization that seeks to tell the stories of persecuted, impoverished, oppressed, or forgotten people in the world. SI provides journalistic photography, video, and writing to tell the stories of people in need. The stories are then communicated to others in order to educate and inspire involvement in providing assistance. SI offers its services to other approved non-profit organizations.

Website: www.silentimages.org
Director: David Johnson
Email: david_johnson@mac.com

A SPECIAL THANKS to the following people who have invested into my life and or this book:

Mom , Dad, Kevin, Katrina, Mary Anna , Fisher, Tate, Larry Warren, Brad Philips, Ed Lyons, Chris Grimes, Bill Teppig, Joshua Lawson, my former English students and tennis players, my friends in Crestdale, *Dilworth Coffee, It's a Grind, and Kudu Coffee House* for use of their coffee shops while I wrote this book, Phil and Laura Sherrill, David Chadwick, Dean Smith, CSO, Tony Stewart, Senator Robert Pittenger, Ty Rhudy (for the inspiration to photograph), Steele Creek Church of Charlotte, Christian Solidarity International (www.csi-int.org), Will Esser, Abbot Placid Solari, "The Matthews Crew," Covenant Day School, David Rea, Evans McGowen, Green Rice Gallery, Stephen Windham, Michael Nixon, Amy Ropp, Todd and Julia Chitester, AK, Bill Schillings, my friends from UNC and Charlotte Catholic, Paul Joyce, Braun Smith, Melissa Jakeman, Brad Greer, Julie Jones, Poulterer Family, Patsy Steimer, Matt Favreau, Roger Fuller, Jr., Mark Stevenson, Kelly Fleming, John Myers, Big Kenny, Shannon Tucker and the English department at Providence Day School.

PHOTOGRAPHY CREDITS

Photo on page 9: Joshua Macleod
Map on page 13: Frontline World
Photo on page 59: Makeway Partners
Photo on page 87: Eddy Messick
Photo on page 57: Persecution Project

All other photos were taken by David Johnson

SOURCES

Timeline: BBC Sudan Timeline 2007
http://news.bbc.co.uk/1/hi/world/middle_east/country_profiles/827425.stm

Map and Facts: *National Geographic* 2007
http://www3.nationalgeographic.com/places/countries/country_sudan.html

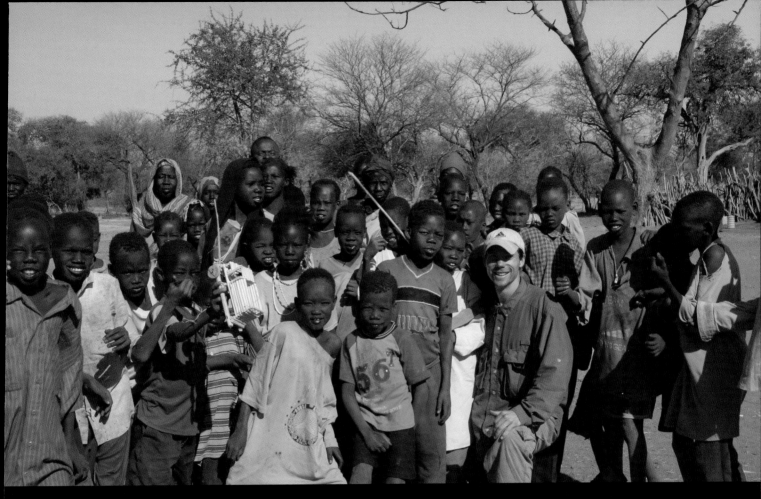

"Hit one ring and the whole chain will resound." - AFRICAN PROVERB

"Speak up for those who cannot speak up for themselves, for the rights of all who are destitute." - PROVERBS 31:8 (NIV)

Although this book is just one "ring," I pray that it will inspire a movement of people who work together to help the Sudanese. After reading this book, I hope you are inspired to share the story of Sudan with others and "Speak up for those who cannot speak up for themselves."

David Johnson

"One of the best things about this growing movement (to help Sudan) is that it is nonpartisan. So much of the venom that marks Washington these days - the red state/blue state divide - has been set aside. How strange it must have been for the conservative evangelical members of Congress to find themselves agreeing with some of the most liberal members the Congress has ever seen!"

DON CHEADLE

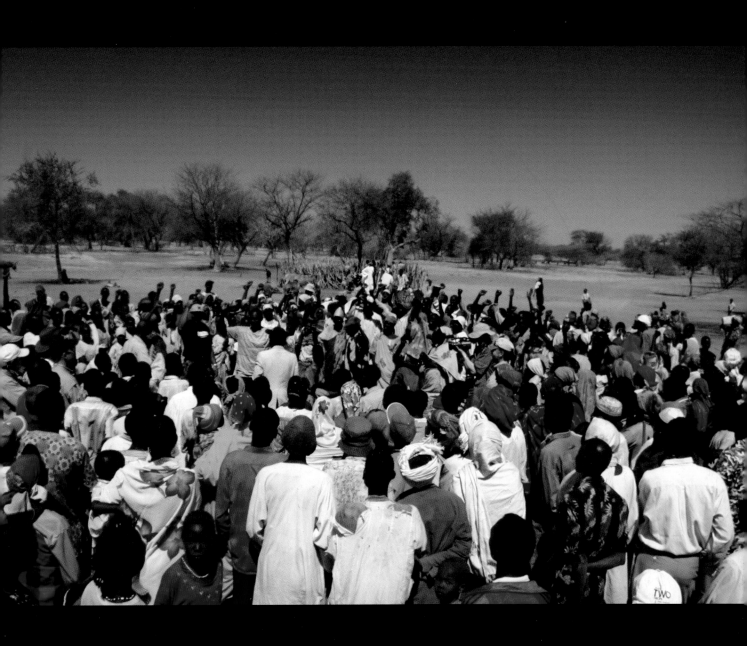

"All that is necessary for the triumph of evil is that good men do nothing."
EDMUND BURKE

SILENTIMAGES.ORG